HAWICK

THROUGH TIME

Alastair Redpath

AMBERLEY PUBLISHING

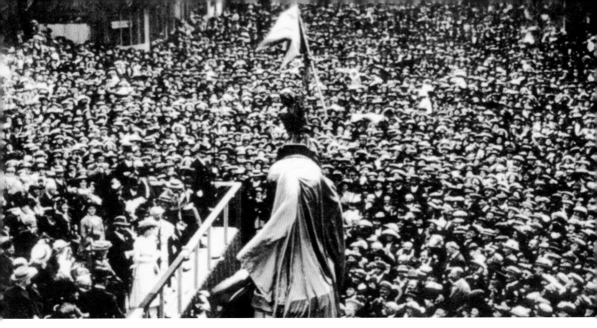

Unveiling of the 1514 Memorial, 1914

This book is dedicated to Jaime-Lynn Moffat, without whom none of this would have been possible

First published 2014

Amberley Publishing
The Hill, Stroud, Gloucestershire, GL5 4EP
www.amberley-books.com

Copyright © Alastair Redpath, 2014

The right of Alastair Redpath to be identified as the Author of this work has been asserted in accordance with the Copyrights, Designs and Patents Act 1988.

ISBN 978 1 4456 3915 4 (print)
ISBN 978 1 4456 3926 0 (ebook)

British Library Cataloguing in Publication Data.
A catalogue record for this book is available from the British Library.

Typesetting by Amberley Publishing.
Printed in Great Britain.

Introduction

Nestled among the rolling Border hills, at the confluence of the River Teviot and Slitrig Water, Hawick is perhaps deserving of its traditional title as 'Queen of all the Borders.' Yet remarkably little is known about the area prior to the twelfth century. A cluster of Iron Age hill forts in the vicinity, at places such as Priest Hill (near Newcastleton), bear no direct historical connection to Hawick. The Romans created an advance post at Trimontium, near Melrose, and a signal station on Ruberslaw, but never ventured beyond a temporary camp at Eastcote, 2 miles east of the town. It is widely believed that the current settlement was founded in the twelfth century, when the Anglo-Norman Lovel family was granted lands by King David I. Here they built a motte-and-bailey castle – a fortification with a palisaded wooden keep on a raised earthwork, surrounded by an enclosed courtyard, protective ditch and a small settlement of houses and farm buildings. Indeed, a popular theory as to the origin of the name 'Hawick' is that it derives from the Old English words 'haga', or enclosure, and 'wic', a dwelling. The Chronicle of Melrose later details the dedication of the church of the Holy Mary in 1214, from which St Mary's kirk can claim an 800-year lineage today.

For the best part of two centuries thereafter, Hawick remained little more than a village, overshadowed by the great Border Abbey towns. This changed by 1511, when a royal charter made Hawick a Burgh of Barony, independent of its feudal lords, and granted the town to Sir William Douglas of Drumlanrig (though it had been in his ancestors' possession since around 1412). The town charter of 1537, afforded by Sir James Douglas (7th Baron of Hawick), noted that the settlement had grown in size, now comprising 110 houses, a manor house, church and mill. These rights were confirmed in another royal charter of 1540 (by the infant Mary, Queen of Scots), with the Burgh's municipal privileges surviving relatively intact until the eighteenth century. It was during this time of the Border Reivers that the medieval town started to take shape. In an era of lawlessness and cross-border conflicts, stone fortifications were built to protect the surrounding land and its people – including Drumlanrig's Tower, the oldest surviving building in Hawick, which dates to the 1550s.

Following the Battle of Flodden Field in 1513, the Earl of Surrey divided his troops under the supervision of Lord Dacre, and permitted raids across the border into Scotland. A group of soldiers camped out at Hornshole on their return to England, and sparked panic in nearby Hawick. The town's young men or 'Callants', were called to arms and soundly defeated the enemy – capturing the Abbot of Hexham's banner as a prize. The 'Hornshole Skirmish' is today celebrated through the annual Hawick Common Riding, which, combined with the ancient tradition of 'riding the marches,' adds to the town's unique and rich heritage.

The urban layout of Hawick did not change much until the eighteenth century. The four gates, or 'ports', were closed at night to help prevent the spread of disease and protect the town from invasion. North Port (Walter's Wynd), East Port (opposite Baker Street), South Port (Cross Wynd) and the West Port (foot of the Loan), clearly marked the limited extent of the town, and very little building took place beyond the High Street, Howegate and Sandbed. It was only in the 1750s, following the Turnpike Road Act, that these gates were removed and the land beyond the town was opened for expansion.

In 1771, a new industry gave Hawick its first steps towards the Industrial Revolution. When stocking frames were introduced by local magistrate John Hardie, the town experienced a boom period of growth and innovation, which, with the exception of the Napoleonic Wars, lasted right until the mid-nineteenth century. The knitwear industry became the backbone of the local economy and attracted many immigrant workers from across Britain and Ireland. From a population of just 2,798 in 1801, Hawick grew to become a large town of over 19,500 people by 1891. The amalgamation with neighbouring Wilton Parish in 1861, long an independent settlement in its own right, contributed to this growth. The period 1850–1900 brought with it large-scale building projects. From the textile mills of Pringle's of Scotland, Peter Scott, Hawick Cashmere and Lyle & Scott, to new roads, bridges, schools, hospitals, churches and sports grounds, Hawick almost doubled in size. A railway to Edinburgh (1849) and Carlisle (1862) further connected the town to the outside world. It was during this time that most of Hawick's cultural and sporting institutions were also established.

The twentieth century brought with it a new training ground for the British Army at Stobs and the continued growth of the local knitwear industry. After the Second World War, Hawick experienced another period of expansion, with new housing schemes at Burnfoot, Silverbuthall and Stirches. The highly controversial closure of the Waverley Route in 1969 deprived the region of a key transport link, with the effects still being felt today. A period of decline came in the 1980s and 1990s, with the loss of hundreds of jobs from the town's traditional employers. This year (2014), however, is set to be an important one for Hawick, with the 500th anniversary of the Hornshole Skirmish. Numerous events and festivities are planned to mark this once-in-a-lifetime occasion.

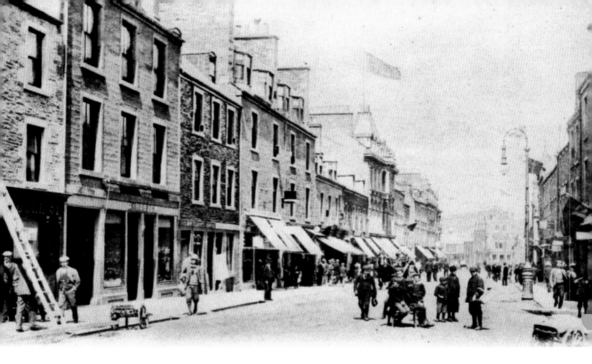

High Street, 1900s and 2014

Hawick High Street has seen plenty of changes from this Edwardian era photograph. No. 51 (left), now occupied by former Scotland rugby international Jim Hay and his estate agency business, was once home to Turnbull's wine and spirit merchants. Founded in 1855 by James Turnbull of Rule-water, this long-established local firm now trades at Oliver Place. Further along to the left lie the distinctive Hawick Co-operative buildings. Known initially as the Hawick Chartist Association, the organisation was responsible for the first local co-operative at No. 1 Silver Street in 1839. The current building dates to 1885, when various outlying enterprises – from shoemaking to drapery – were consolidated under one roof. The store sadly closed in 1987, although the building remains occupied by a number of retailers.

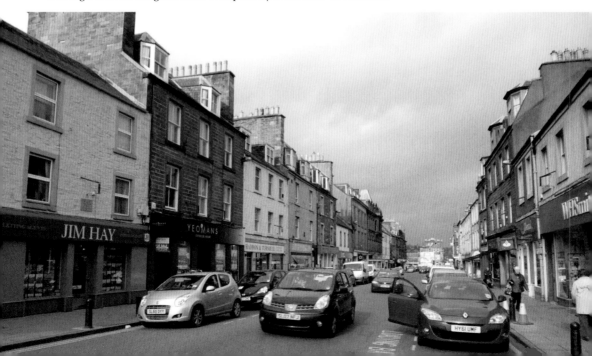

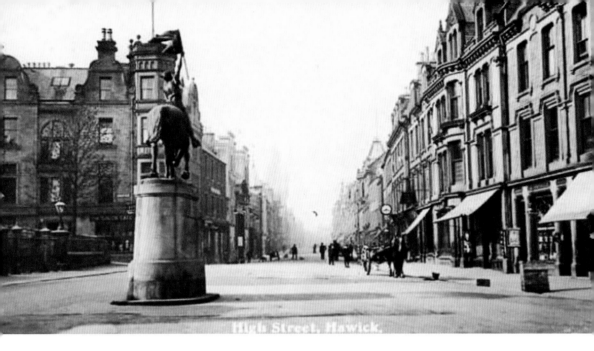

High Street, Hawick.

High Street, *c.* 1907 and 2014

Hawick Liberal Club (left) was built on the site of George Milligan's cabinet-making business in 1894. Rooms above Milligan's housed the town's original museum in 1858 – a collection of works by the Hawick Archaeological Society. The Liberal Club was erected at a cost of £6,000 and was designed by local architect J. P. Alison. The Green Café also once occupied the corner of No. 80 High Street/No. 1 Brougham Place. This fondly remembered business was established in 1838, and continued to trade until 1999 before becoming a sweet shop. For now, the future of this iconic building remains uncertain.

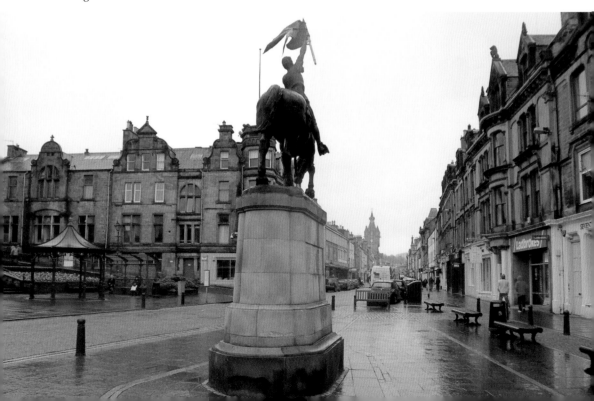

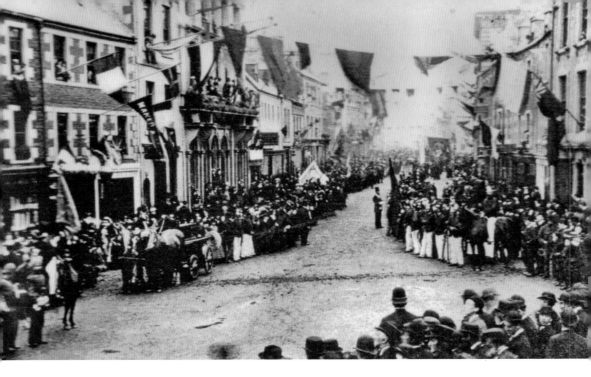

High Street, 1890s and 2014

The High Street, as in most Scottish towns, was often the central hub for commemorating events and occasions, as seen in this unknown gathering from the 1890s. The building with the distinctive balcony on the left is the former British Linen Bank, designed by company architect David Cousins. Built on the site of the Ruecastle Tenements in 1862, the Hawick branch operated as an independent company until 1971, when it merged with the merchant arm of the Bank of Scotland. No. 7 is now a Category B listed building.

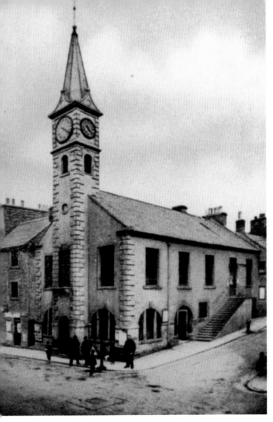

**Hawick Town House, *c.* 1880,
and Hawick Town Hall, 2014**

Hawick Town House, predecessor to the current
town hall, was built around 1781 on the site of
the old Hawick Tollbooth. It incorporated a bell
to complement the one at St Mary's kirk, which
was used to call the nightly curfew. The building
was part funded by the Duke of Buccleuch, who
contributed £100 to its construction, plus half
the cost of paving the surrounding streets. The
ground floor at Cross Wynd had open arches,
which were closed at night with iron gates. This
was the location for the town's meal and butter
markets, while the main council chambers were
located upstairs. The building was demolished in
1884 in preparation for the new 'Toon Ha'.

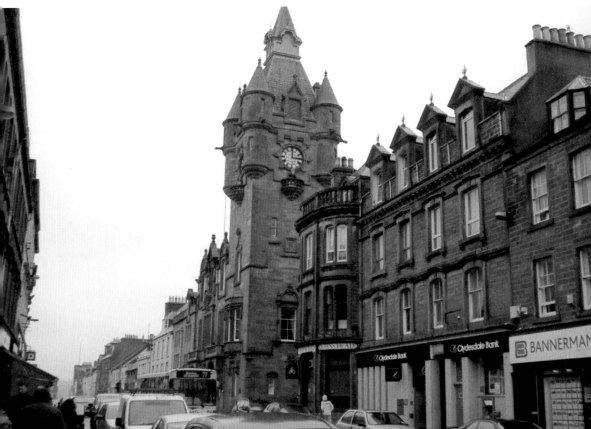

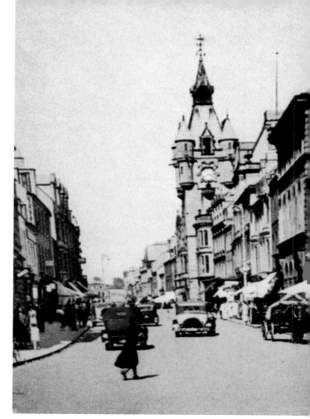

**Hawick Town Hall,
Early 1920s and 2012**

The demolition of the old town house took place in early 1884. Architect James Campbell Walker had won a competition to design the new town hall a year earlier and his plans were executed by John and William Marshall at a cost of £16,000. The building originally housed a police station as well as municipal offices; indeed, a few cells remain along a back corridor. Although the station closed in 1964 (when a purpose-built divisional headquarters was opened at Wilton Hill), Cross Wynd is still occasionally referred to as Policeman's Brae. The lesser function hall was added during the 1950s.

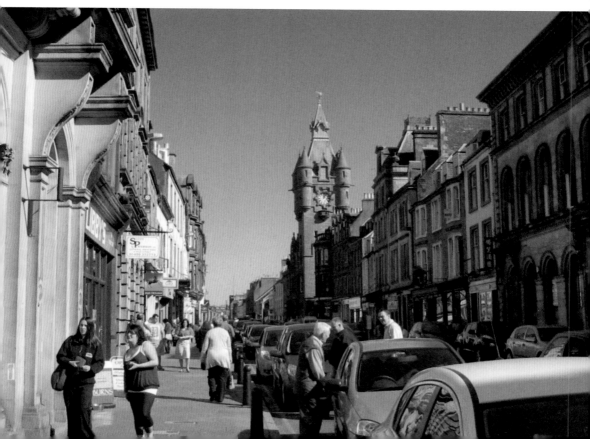

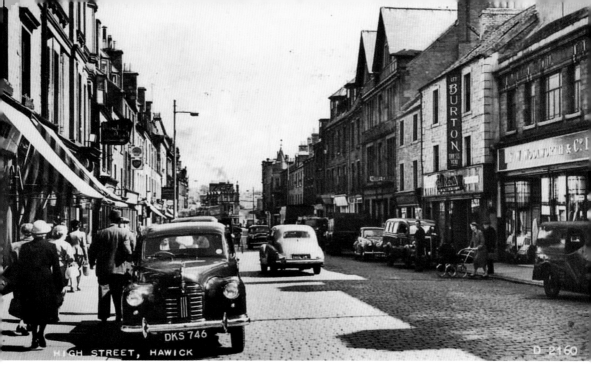

High Street, 1956 and 2014

A very lively Reliable Series postcard from the 1950s. The old KS car plates are from the registration offices of Kelso and Roxburgh county. On the right is F. W. Woolworth & Co. Ltd, originally a 3*d* and 6*d* store, which was more popularly known as 'Woolies'. It opened at No. 46 High Street in 1930 as the first such store in the Scottish Borders (Galashiels got its own branch in October 1932). The building was decorated in an Art Deco style, with symmetrical frontage, five bays and a central pediment – much like that of the company's Penrith store. During the 1960s, the shop frontage was replaced with contemporary Woolworths branding, a granite stall riser and metal-framed doors and glazing, while the original brick- and stonework was also covered with a coat of cream-coloured paint. Store 413 closed in January 2009 when Woolworths went into liquidation.

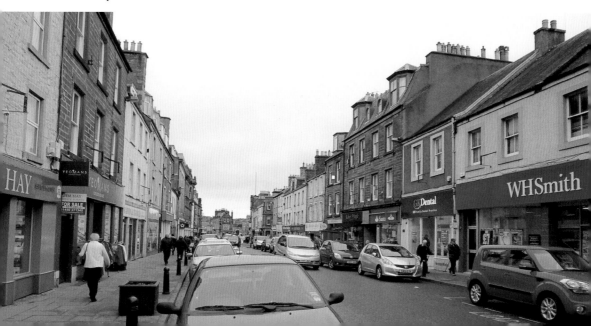

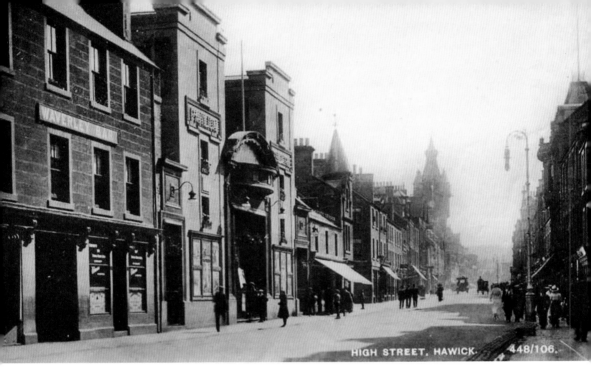

High Street, 1920s and 2014

The Waverley Bar (left) was established on the site of the town's East Port. It inspired the creation of Hawick Waverley AFC, Hawick Waverley Union FC (a junior rugby club from the early twentieth century), while Hawick Trades RFC also had club rooms to the rear of the premises. The Pavilion Picture and Variety Theatre or 'Piv' (above, left) was a spacious cinema located at Nos 74–76 High Street. It was built in 1913 and originally staged theatrical performances as well as films, and could seat 1,400 people. The complex was demolished in 1964 to make way for retail units, now occupied by a branch of Boots.

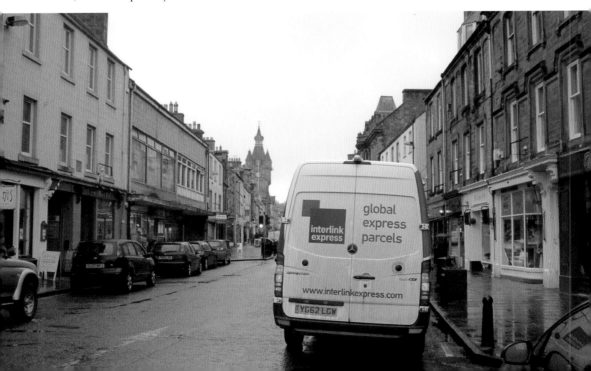

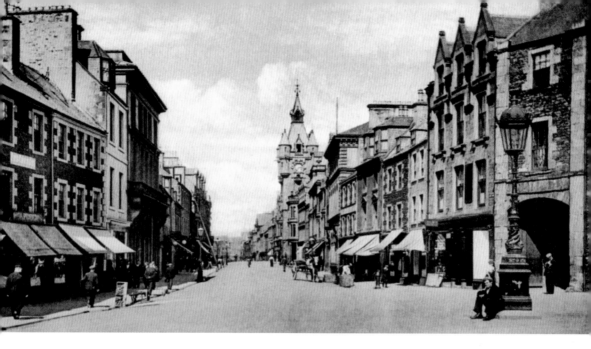

High Street and Tower Knowe, *c.* 1902 and 2014

The slight rise of the street just outside Drumlanrig's Tower, which was later lowered, lends its name to the 'Knowe' of Tower Knowe, which means a small, rounded eminence. In the foreground, you can see a distinctive lamp post. The official appointment of Lamplighter began on New Year's night in 1813, with sixty oil lamps initially located at key points across the burgh. Locals dubbed the lighters 'Wee Winkies', after the flickering flames they carried, which cast a dim light on the uneven road surfaces. They set the lamps nightly from November until April, using Train Oil (a term for Whale Oil, which comes from the Dutch word *traan*). Gas lamps were introduced in 1831 and electric lighting was brought in by 1901, with the establishment of the Urban Electric Supply Co. on Commercial Road.

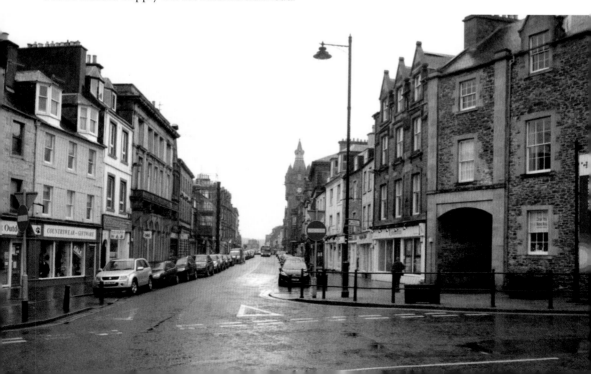

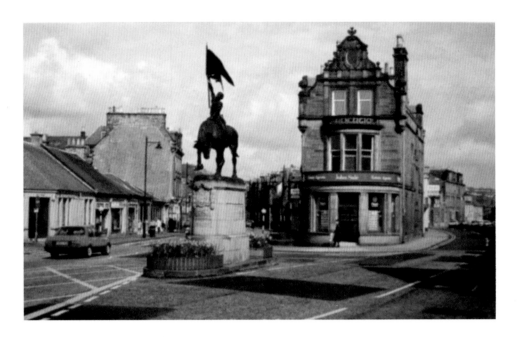

Central Square, 1990s and 2014

The 1514 Memorial – better known as 'the Horse' – was moved in 2003 from its traditional position at the head of the High Street, as part of a £500,000 traffic relief scheme. During the works, a time capsule dating from 1914 was discovered and its contents displayed in local jeweller Hamish Smith's shop window (just out of shot, right). A new capsule was later buried with the original. Engineering specialists Specpro were called in by contractors Barr Construction to oversee the 27-ton bronze sculpture move a mere 5 metres. It took twenty minutes in total.

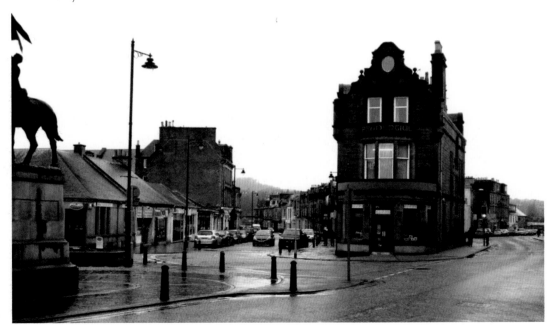

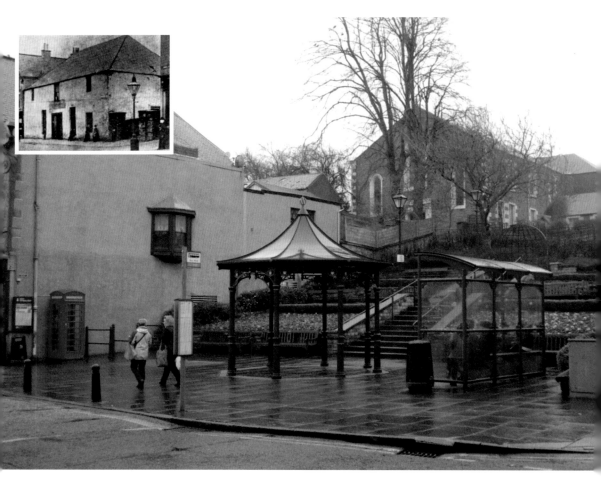

East Bank Kirk, 1900s, and Trinity Gardens, 2014

East Bank kirk was built in 1780 on land once known as the Wheathole. In 1847, it became part of the United Presbyterian Church, while an offshoot formed in 1886 went on to become Wilton South church. The original structure was an unpretentious, square, two-storey building with an attached church hall. An adjacent manse was built in 1793. The old meeting house was converted for use as a private school for a few years (the forerunner of Saint Mary's and Trinity schools), and was last used by a joiner's firm in the early twentieth century. When the building was demolished, Trinity Gardens were created in its place.

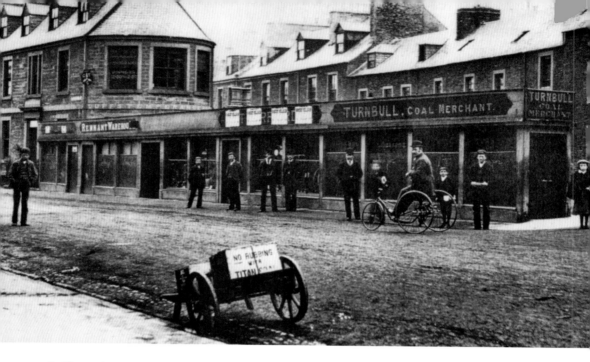

Coffin End, 1890s, and The Pru', 2014

The bottom half of this building is still referred to as the Coffin End, after its once distinctive shape. Built around 1857, it housed the Washington Hotel and later Duff's Temperance Hotel until 1893. Its 1894 replacement now dominates the top end of the High Street, with its bowed ground-floor frontage and bold Dutch gable. The balcony balustrade originally read 'The Central', but was modified to 'Prudential' when the insurance company took over the building around spring 1919, at a cost of £2,300. It has since been home to many businesses, including a letting agent, Findlay's restaurant and the Coffin End Café, but now hosts the popular Rum & Milk shop.

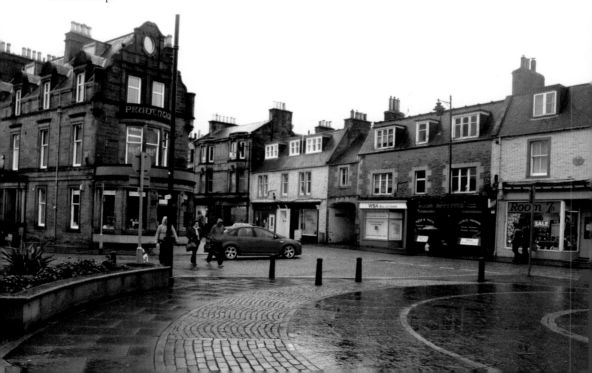

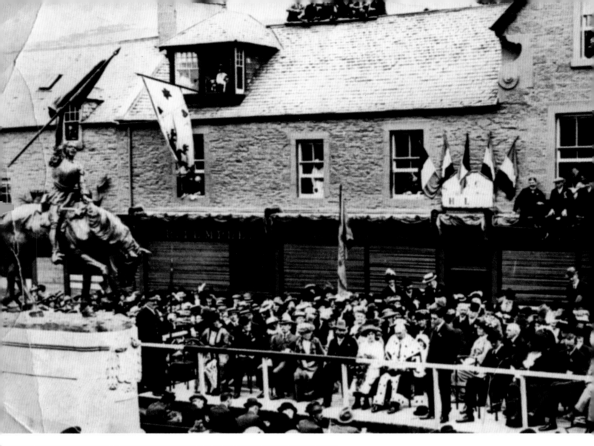

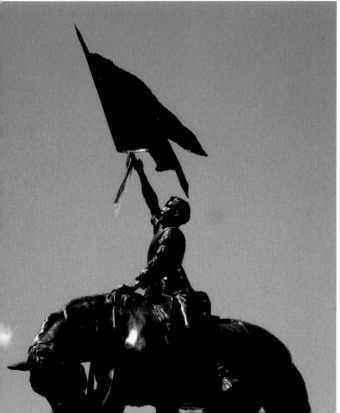

The 1514 Memorial, 1914 and 2013

The 1514 Memorial was unveiled on 4 June 1914. Better known as 'The Horse,' the monument was designed to commemorate the 400th anniversary of the Hornshole Skirmish and was financed wholly by public subscription. Two months after this event, sculptor William Beattie was called to active service in France. He was awarded the Military Cross in 1917 for carrying wounded soldiers to safety under heavy shellfire. After a spell back in Britain recovering from the effects of a gas attack, he was given a temporary promotion from Lieutenant to Acting Major. William was fatally wounded in action and died at a casualty clearing station in France on 3 October 1918. Today, his lasting legacy remains Hawick's most famous landmark.

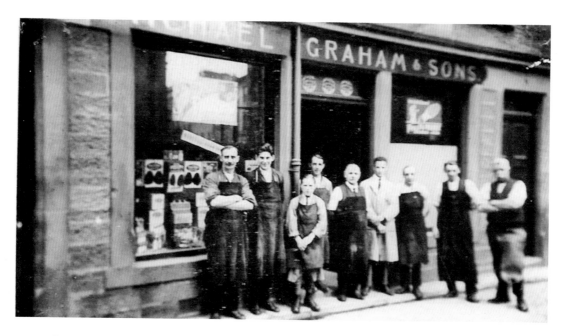

Silver Street, 1920s and 2014

Michael Graham & Sons – cobbler's and bootmaker's – was established at No. 2 Silver Street in 1881, as the largest producer of clogs and tackets (a small stud for a shoe; a hobnail) in the local area. Clogs were a common choice of footwear in the town before the twentieth century. The higher platforms allowed people to avoid dirt, raw sewage and cart tracks on the roads during a time when pavements were not commonplace. Wooden-soled shoes also came back briefly while leather was scarce during the Second World War. Today, the site is occupied by the Damascus Drum café and second-hand book shop.

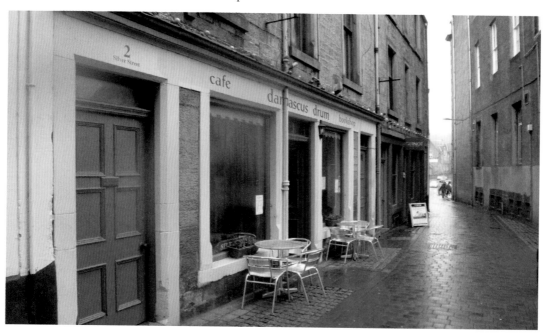

Marina Entertainment Centre, 1985, and Heart of Hawick, 2014

The Hawick Exchange Company was set up in 1861 and land for a new Corn Exchange was gifted by the 5th Duke of Buccleuch, the 'Good Duke Walter'. Funds were raised by subscription to a private company. Around 1910, it was acquired for showing 'moving pictures', and was refurbished and renamed the King's Theatre in 1920. After a spell as the Odeon and the Classic, the buildings were given a new lease of life as the Marina Entertainment Centre and Humphrey's Nightclub/Bogart's Bar in around 1980. In 1992, a fire gutted the Exchange buildings, causing damage estimated at over £2 million. The remains were preserved, converted and extended in 2005 as part of the multi-award-winning £10 million Heart of Hawick Project.

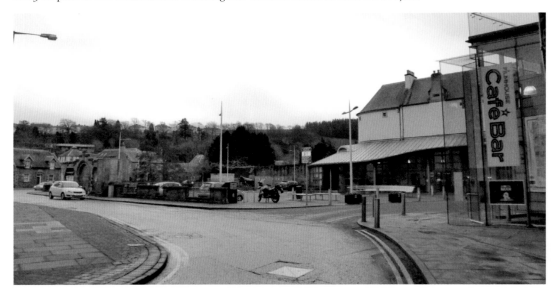

Marina Entertainment Centre, 1994, and Heart of Hawick, 2014

This was the Arcade end of the Exchange buildings, which once housed a number of lucrative studios. Photography was a competitive business in Hawick during the late nineteenth century. John Edward Dodd Murray (born 1858), popularly known as 'Jed', became 'Hawick's Photographer', despite competition from Robert Bell and Thomas T. Wilkinson on the High Street, Jenner & Co. in the Arcade, and G. Allen Robinson just along Bridge Street. Such was Murray's popularity that he was made Cornet in 1890. Jed died in 1936 but his son Melgund remained in business at their North Bridge Street premises until 1972. The Arcade was destroyed by fire in 1992, although its distinctive entrance archway remains in situ, as seen in the photograph below.

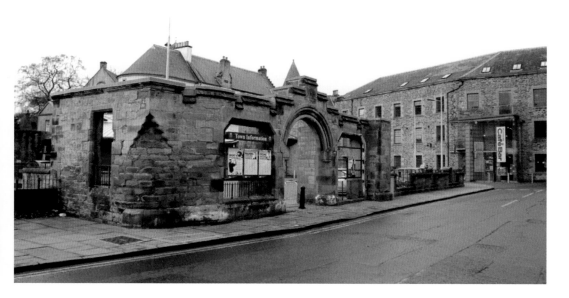

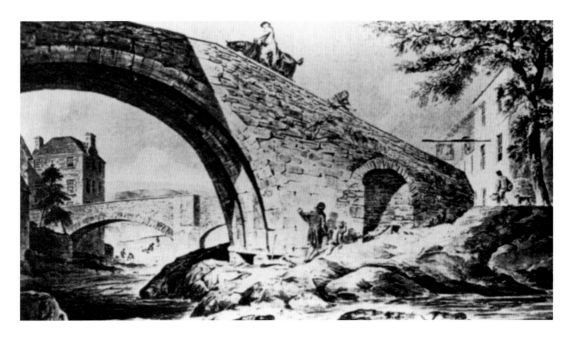

The Auld Brig, 1800s, and Tower Mill, 2014
For several hundred years, the Auld Brig was Hawick's only major spanning of the Slitrig or Teviot. It is said to have dated from the late thirteenth century. The structure had two semi-circular arches, the larger one having a steep slope on the west side and the smaller arch having a gentler slope on the east side. It was intended for foot traffic only, as it was high, narrow and quite steep. Having survived the great Slitrig flood of 1767, the Auld Brig was demolished in 1851 to make way for Tower Mill. Today, the span of the bridge coincides roughly with the position of the Heart of Hawick's theatre.

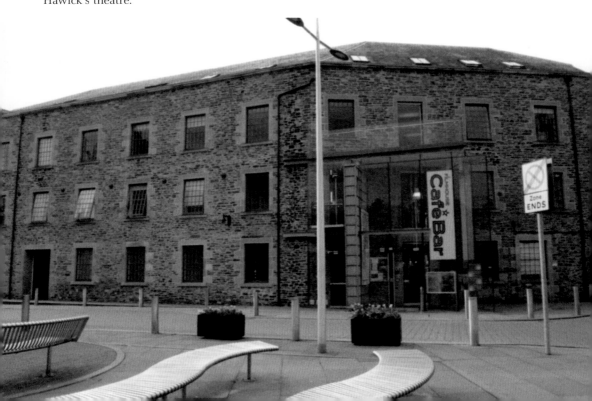

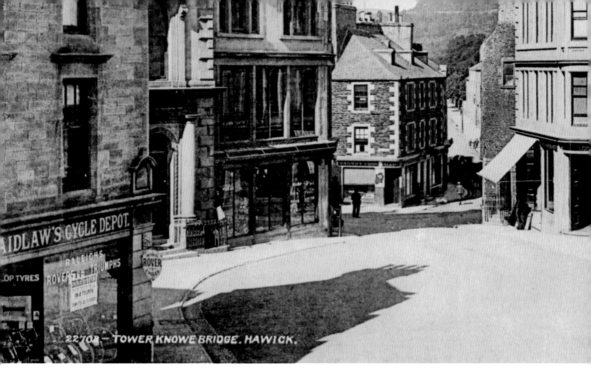

Drumlanrig Bridge, *c.* 1902 and 2014

William Laidlaw's Cycle Depot was founded during the 'bike boom' of the late nineteenth century, during which time two local organisations were created – Teviotdale Cycling Club and Hawick Cycling Club. Drumlanrig Bridge, over which these buildings stretch, was originally known as Slitrig Brig and was built by public subscription in 1776, using stone from Bedrule quarry. It was widened in 1828 to facilitate the market that met there, and further widened to triple the original width in 1900, with the stone parapets replaced by ornamental ironwork. Further structural strengthening work took place in 1978.

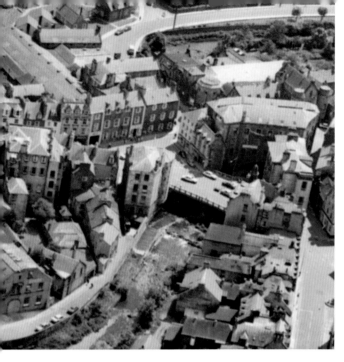

**Hawick from Above, 1981,
and Tower Mill, 2014**
Tower Mill (seen in a semi-derelict state on the left) is a Category A listed former spinning mill, built in 1852 on the site of the town's Auld Brig. It was unique in Scotland as the only mill to be built on a bridge and for having the largest surviving waterwheel in southern Scotland. The building fell into disrepair during the mid-1980s and ownership was transferred to the Scottish Historic Buildings Trust in 1995. Today, it is managed by Scottish Borders Council as an integrated theatre, café and arts centre.

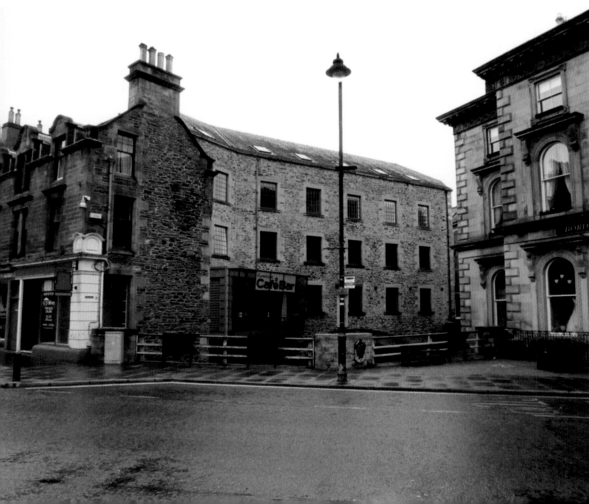

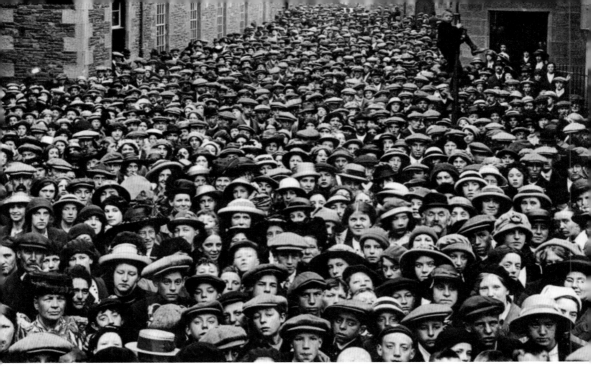

Kirkstile, 1914 and 2014

The ceremony seen above, known as 'The Snuffin', harks back to an old social custom of passing round the snuffbox during rest breaks at the annual Common Riding. To the left is Silver Street, a narrow street alongside the west bank of the Slitrig. It is one of the oldest streets in Hawick, although most of the present buildings date to the Victorian era. Up until the latter part of the eighteenth century, it formed part of the main road through Hawick, and houses there were referred to as being on the 'King's High Street.' It became more of a back route with the erection of Drumlanrig Bridge in 1776, and more so with the demolition of the Auld Brig in 1851.

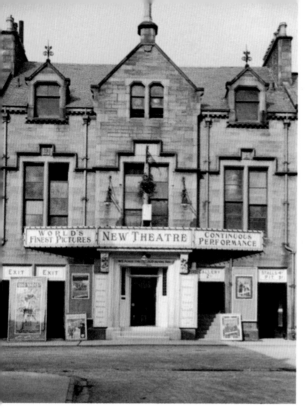

Wee Theatre, 1914, and Croft Road, 2014
'We place the world before you', says the sign outside the 'Wee Thea'. More properly known as Hawick Picture Theatre, it was built in 1901 to a design by J. P. Alison. From around 1905, the building also housed the town's main Temperance Hall and organisation, a predecessor of the Salvation Army. The site was renamed the New Theatre Picture Palace in 1913. The interior had three levels: the stalls, dress circle and the gallery (known as 'the Gods'), with plush red seats and plaster-gilt crowns around its front. The building was sadly destroyed by fire in 1955 and was demolished by 1960. The site was used to build the current Salvation Army Citadel in 1961.

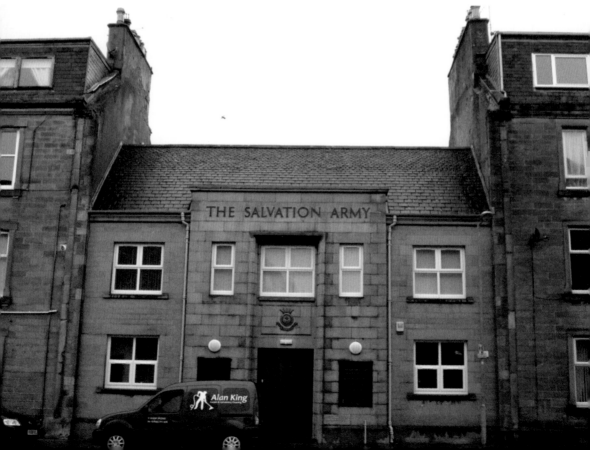

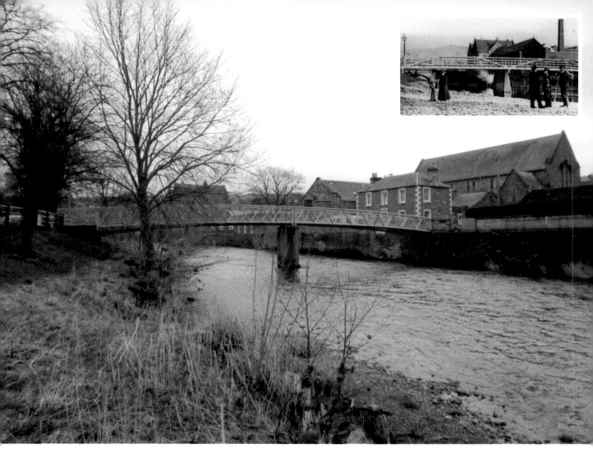

Lawson Footbridge, 1886 and 2014

Lawson Footbridge is named after Alexander Sutherland Lawson (1842–1916), who bequeathed money for its construction. He was a member of the town council for over forty-three years, as treasurer, bailie and later a judge. He was also a founding member of the Common Riding Ceremonial Committee in 1887. In 1904, a cast-iron bridge replaced the original wooden structure, with steps leading to both ends. The second bridge was in turn superseded by the current design, which was unveiled in 1988.

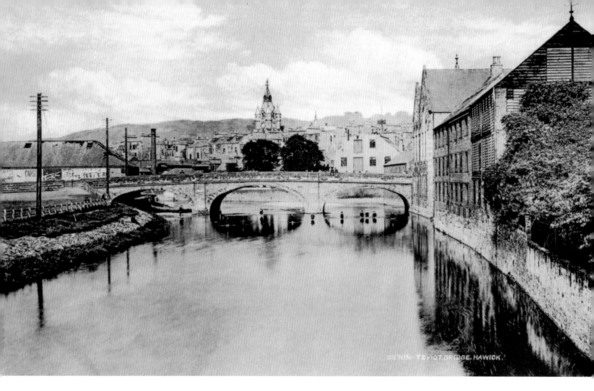

Teviot Bridge, *c.* 1902, and Albert Bridge, 2014
The dilapidated building (left of the bridge) at the foot of Albert Road was once the site of the town's gasworks. This area was cleared to make way for the Burns Club in 1928. The Teviot Bridge, often called the Albert Bridge, was built in 1865 and consists of three elegant segmental arches. This structure replaced a previous crossing of the Teviot dating from 1741, and was designed by architect Andrew Wilson. The current name derives from an error on the 1898 Ordnance Survey map, which has since stuck.

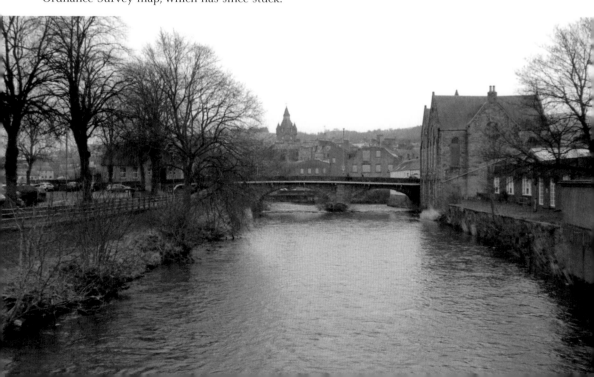

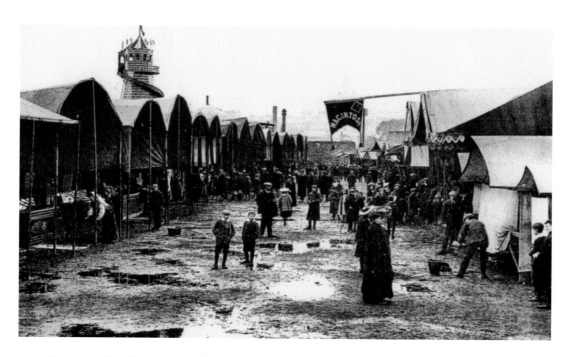

Common Haugh, 1907, and Common Haugh, 2014

The Common Haugh has been in the possession of Hawick since at least the late fifteenth century, being used mainly for social events and as a venue for the town's market. It once stretched from the Cauld all the way to North Bridge, although large parts were feued off in the eighteenth and nineteenth centuries. The annual Common Riding races and festivities took place here until the opening of St Leonard's Racecourse, while the town's original Auction Mart was founded here in 1817. It remains a part of the Common Good – inherited public property from the former Burgh of Hawick.

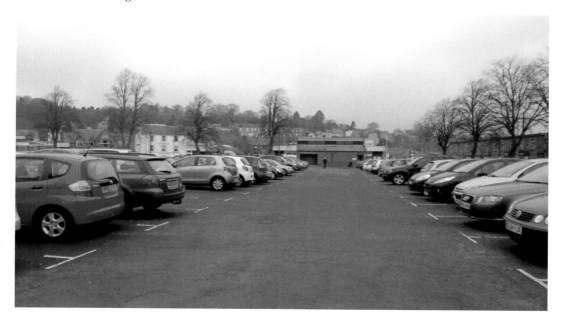

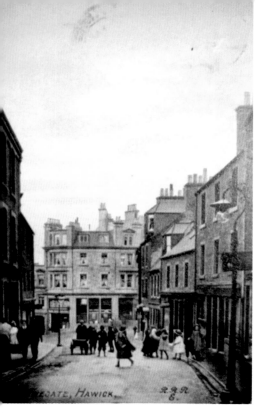

Howegate, 1910 and 2014

The distinct curve of the Howegate follows a post-medieval route into Hawick. Its name derives from the Old English 'Haugr' (meaning hill) and 'Geat' (meaning entrance), which was corrupted over time to the Scots 'Howegait'. During the eighteenth century, housing spread upwards from the Sandbed to meet common grazing lands at the Loan. In the nineteenth century, much of the area was demolished or remodelled – something derided by Hawick's forefathers. An extensive redevelopment of the area took place from 1978 to 1982, headed by Aitken Turnbull, which saw many of the older buildings developed into social housing. The scheme received several Civic Trust Awards.

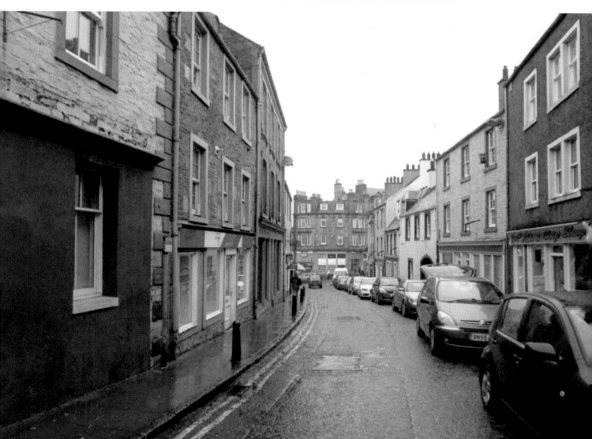

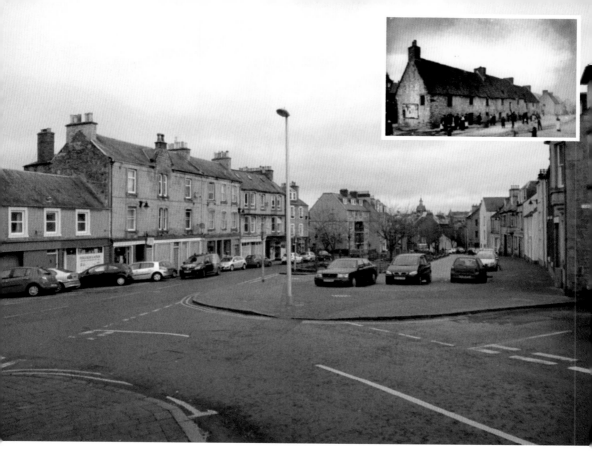

Auld Mid Raw, 1880s, and Drumlanrig Square, 2014

Drumlanrig Square is named after the 7th Baron of Drumlanrig, Sir James Douglas, who granted the Hawick Charter of 1537. Previously known as the Playlaw, and simply as the Raws, the current name did not settle until after the demolition of Auld Mid Raw (pictured above) in 1884. The Raws were rows of pended, thatched tenements dating from the late sixteenth century, and were among the oldest buildings in the town. Each one was named relative to their position to Saint Mary's kirk – Fore, Mid and Back. The buildings were replaced by the George Thomson Fountain in 1897, and it was not until 1910 that the current Brown memorial fountain, gardens and clock were erected.

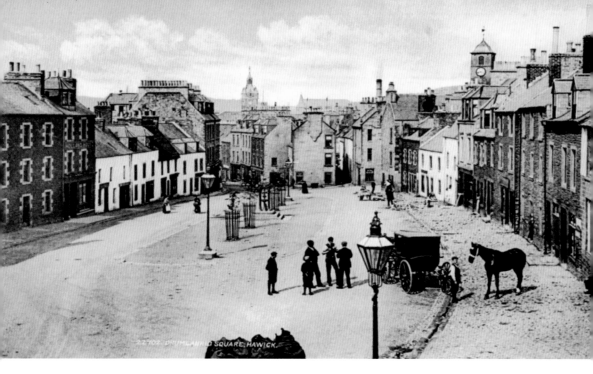

Drumlanrig Square, *c.* 1902 and 2013
From the demolition of Auld Mid Raw in 1884 to the building of the George Thomson Fountain in 1897, Drumlanrig Square was the site of a simple public garden. William Brown JP, auctioneer and house factor, had moved to Alloa from Hawick in his teens. Following his death in September 1908, a new memorial gardens, fountain and clock were designed for the Square. This connection can be seen in the coats of arms of both Hawick and Alloa in the cartouches of the clock's north-west and north-east sides.

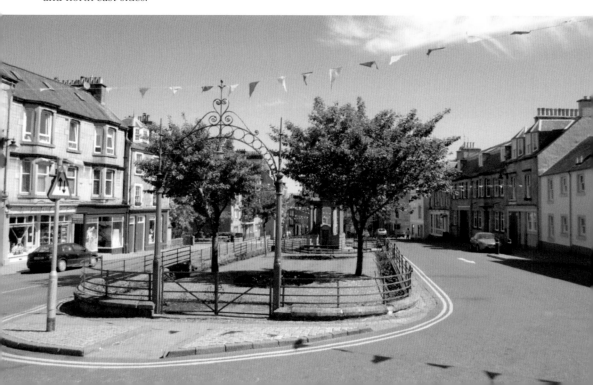

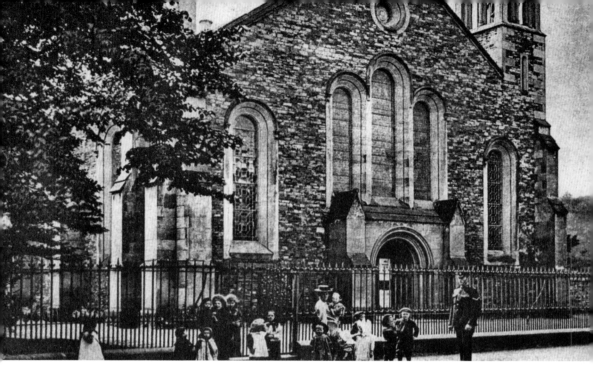

Buccleuch Road, 1905 and 2014

This area of the town was once known as 'the Acre', being a field near the old Burgh boundary. It was gifted by the 5th Duke of Buccleuch to Hawick parish in 1840. Designed by architect William Burn, the new church was opened in October 1844, with adjacent halls added in 1885. The building continued to serve generations of Hawick worshippers until the onset of dry rot in the 1980s. It closed in 1987, with a final farewell service in 1989, conducted by minister David L. Wright. Frank Scott Court, which now occupies the site, is named after the former Hawick Provost and was opened in 2002 – incorporating an old bell from the parish church belfry.

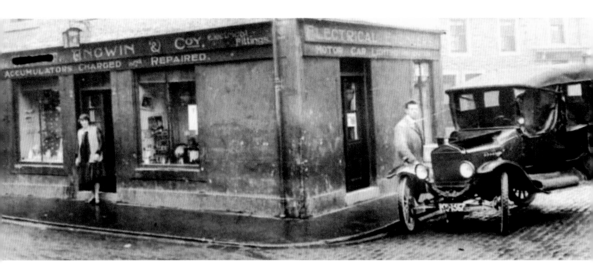

Corner of Buccleuch Street/Orrock Place, 1920s and 2014

This building at the corner of Buccleuch Street/Orrock Place is a Category C listed structure that dates from the early 1800s. It is notable for predating the town's expansion along Buccleuch Street to the west, which began in 1815. It was operated as a hostelry by Robert 'Lurgie' Wilson in the first half of the nineteenth century, called the Burns Inn. He authored the first complete history of Hawick in 1825. Arnot, Angwin & Coy (above) occupied No. 2 for only a short time – the company was dissolved in April 1927 by mutual consent, following the retiral of partner William Arnot. After the Second World War, the building housed an ironmonger's and an antiques shop. It was converted and restored in 1991 as a clothes shop.

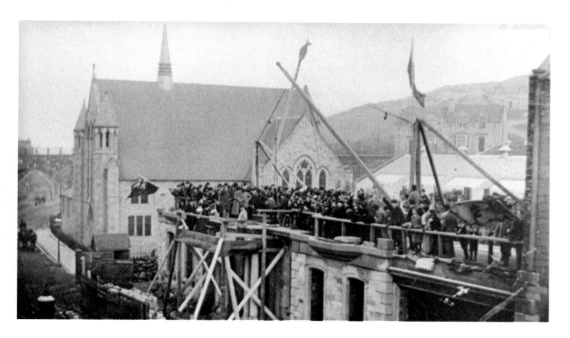

Bourtree Place, 1897 and 2014

Hawick Conservative Club was founded in 1895, with meetings first held in the town's Temperance Hall. They moved to No. 22 Bourtree Place in 1897 (the site of the old East Toll), at a cost of £3,976. Designed by J. P. Alison, the new club contained a billiards room, a bar and a large function room upstairs. In 2011, the club moved to the former post office at the corner of Croft Road/North Bridge Street. Their old premises were taken over by pub chain J. D. Wetherspoon and renamed the 'Bourtree' – because of the elder or Bour trees that once grew here.

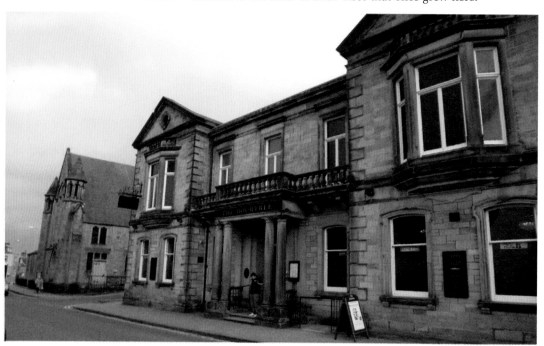

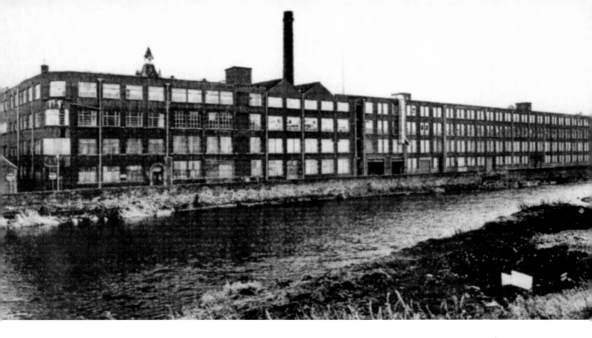

Teviot Crescent, 1970s and 2014

The original buildings of Walter's Wynd were erected for John Nixon & Sons in 1869 and renamed 'Rodono' by Pringle, after the hunting lodge at Saint Mary's Loch that Robert Pringle leased. There was a large fire here in 1939, destroying the offices and much of the company archives. The buildings were developed to their final capacity through extensions from 1952 to 1968. Closed in 1976 due to rising production costs, the machinery was moved along the Teviot to Glebe Mills and the factory administration to the nearby Victoria Mill. The building was demolished in 1980, with the rubble used to fill part of Weensland Dam. The land was chosen as the site of the town's new health centre in 1989.

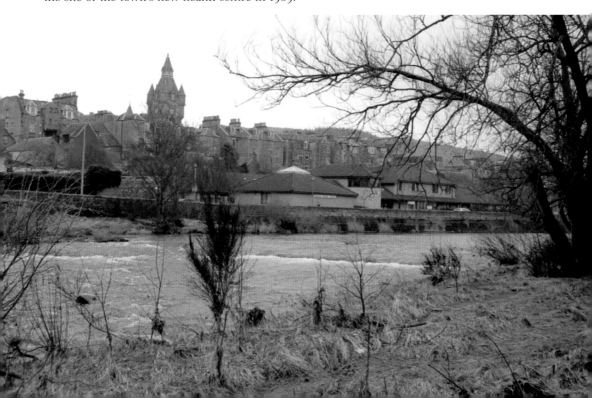

St Mary's Kirk, 1920s and 2014
The year 2014 marks the 800th anniversary of the founding of a church at this location. The present Saint Mary's kirk was constructed in 1764 and reconstructed in 1883 after a fire. This street was formerly known as Easter Kirkstile, and was at one time the formal address of the kirk. Kirkstile now refers to the steps in the wall of the churchyard that lead up to the graveyard. In 1817, a guardhouse was established here by the Town Guard, an organisation set up to protect Hawick's recently deceased from any resurrectionists. Every night, three men were selected by ballot to patrol the grounds.

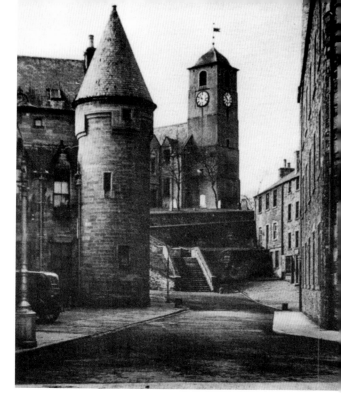

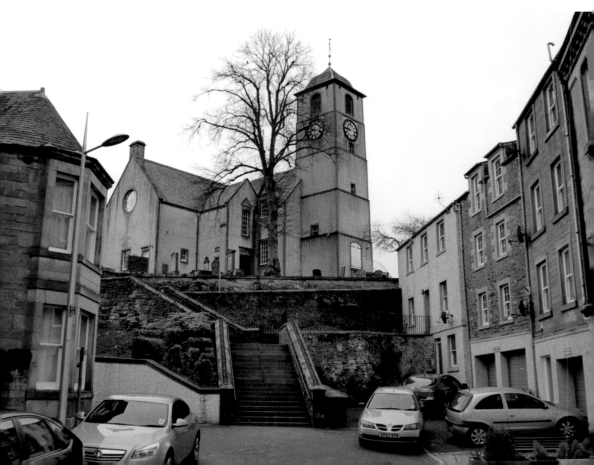

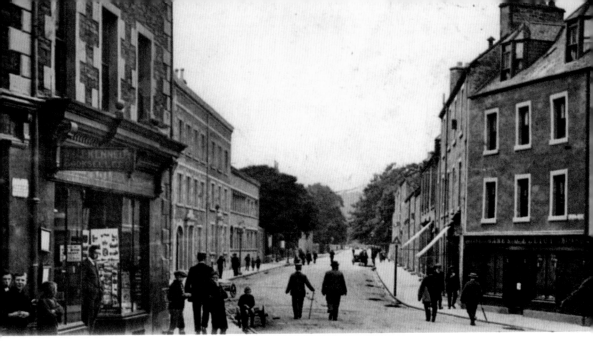

Sandbed/Buccleuch Street, *c.* 1914 and 2014

W. & J. Kennedy (left) was a prominent Hawick-based bookseller at No. 2 Sandbed. It was founded by James Damone Kennedy, and then continued by his sons, Walter and James. They ran a circulating library from the 1830s, one of the first in the Scottish Borders. The company left the Kennedy family in the early 1960s, and closed in 1971 after 142 years, following a compulsory purchase order by the council as part of the Howegate redevelopment scheme. Hosiery firm Peter Scott & Co. (further on the left) originated in a small workshop at Wilton Grove in 1878. By 1897, Scott moved his operations to their current premises on Buccleuch Street, to a building dating back to 1815 when Hawick's 'new road' was first laid out.

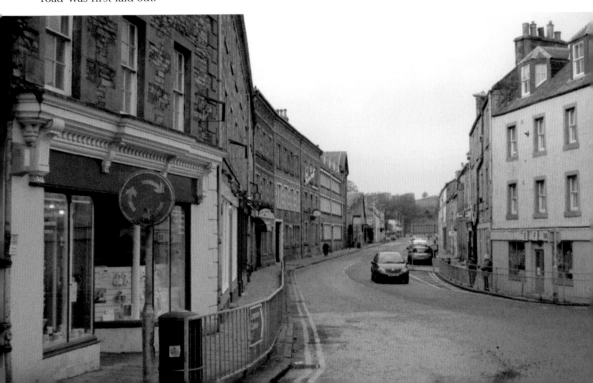

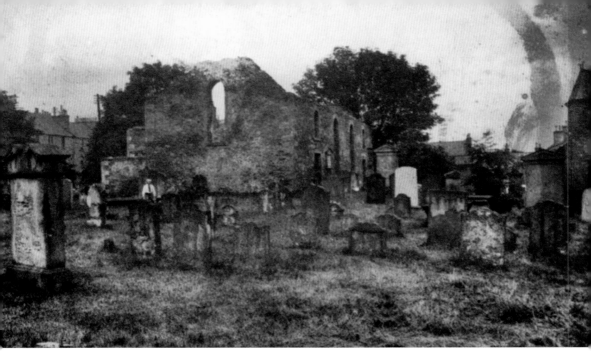

Princes Street, c. 1900 and 2014
Wilton Auld kirk was built in 1762, at the centre of the old Wilton parish burial ground, off modern-day Princes Street. This building replaced a pre-Reformation chapel. A cornerstone from that building is all that survives of either kirk. The earliest graves in the cemetery date back to 1606. Although enlarged to the north in 1801 and repaired in 1829, the kirk was closed in 1861 and replaced by the new Wilton church on Dickson Street. The building was latterly used as a mission hall. Headstones were removed in 1957, as were the railings and wall in 1961, and all but a few notable stones remain today.

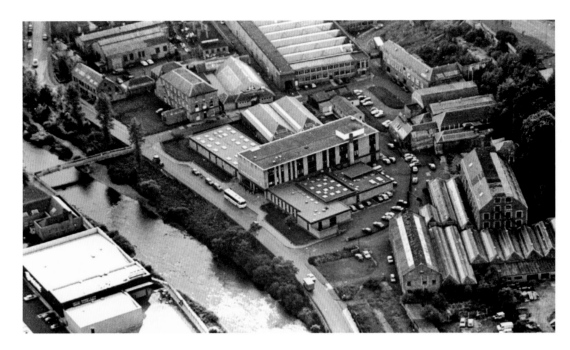

Commercial Road, 1985 and 2014

The aerial shot shows a rich variety of buildings off Commercial Road during the 1980s. Dangerfield, Rough Heugh, Langlands, and Ladylaw Mills once formed the backbone of commercial activity on land feued from Hawick Common, which gave rise to the name of the adjacent thoroughfare. The origin of the word 'tweed' is attributed to a transaction involving Dangerfield Mill. In 1830, a clerk in London misread the Scots word for twill, 'tweel', written on packaged cloth and changed it to 'tweed', like the Border river. The gradual decline of these mills, and the demolition of the former Technical College in 2003, paved the way for a new supermarket and petrol station.

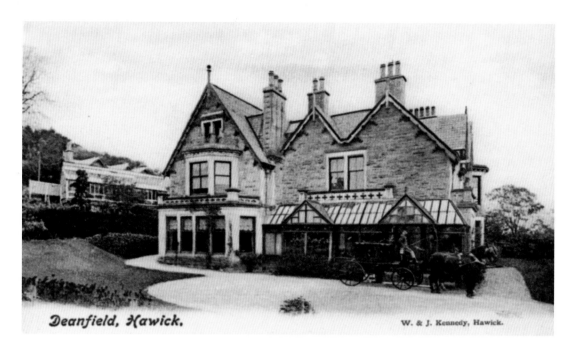

Deanfield, Hawick. W. & J. Kennedy, Hawick.

Deanfield, 1890s and 2014

This was formerly the site of Langlands boathouse (which existed well into the nineteenth century), on the north bank of the River Teviot. It allowed members of the Langlands Estate the luxury of quick travel across the river on small boats known as 'cobles'. Indeed, the nearby Coble Pool derives its name from this practice. Plans had been issued to build a mansion house here in 1850, although it wasn't until 1879 that Deanfield House was built for Charles Wilson of Wilson & Glenny's Mill. The house was demolished in 1973, and replaced with Deanfield residential home.

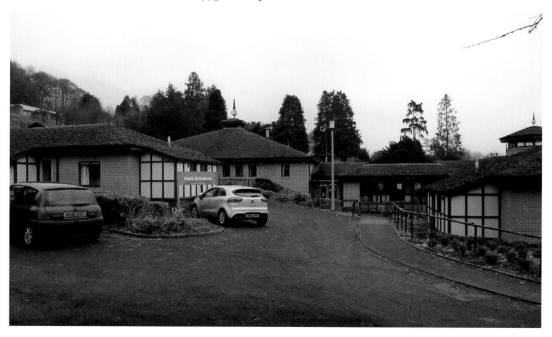

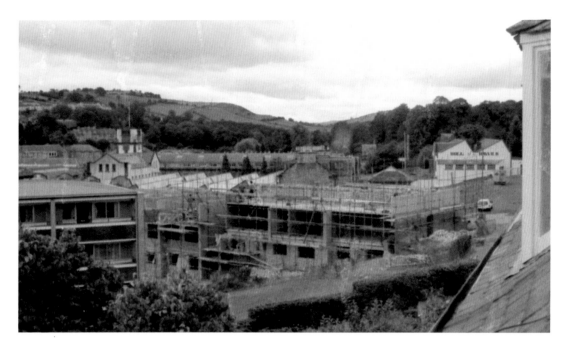

Langlands, 1984 and 2014

Langlands once formed the eastern portion of Wilton Parish. The original terraced housing of Langlands Bank and Terrace was built in the 1850s and demolished to make way for social and sheltered housing in 1984. Langlands Court was built on the site of Saint Margaret's church, built in 1886 on what was then Wellington Street. Originally called the Wellington kirk, it was renamed and created a *quoad sacra* church in 1896. After the congregation merged with Wilton South in 1940, the building reverted to commercial use until its demolition in 1976.

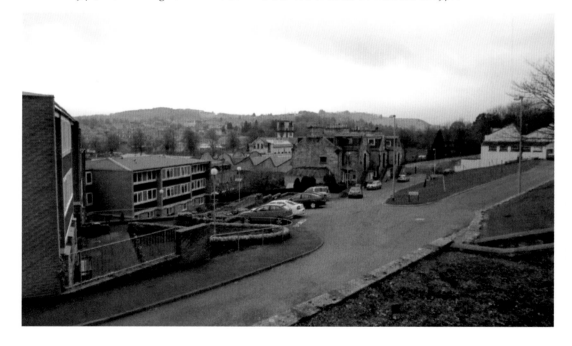

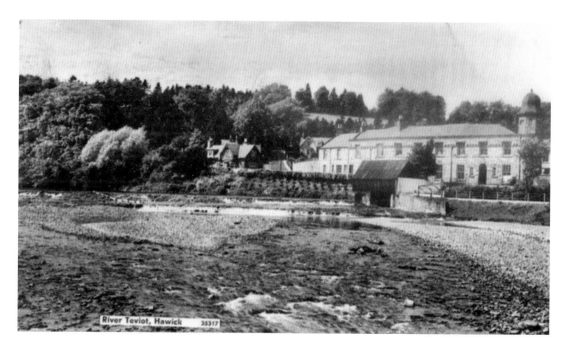

River Teviot, Hawick 35317

Victoria Road, 1962 and 2014

Howlands Mill, at the western end of Victoria Road, was built by Greenwood, Watt & Co. in the 1880s. In the late 1930s, it was sold to Innes, Henderson & Co., and was incorporated into the larger Victoria Mills complex. The mill was demolished in 2004 to make way for Hawick Community Hospital. Some of the stone was recycled in the base of the Steve Hislop statue in Wilton Lodge Park. The Cauld is a purpose-built weir at the west end of the Common Haugh, built to divert water for the mill lades system that passed through Wilton. It is now the scene of the Dipping of the Flag and boundary-marking ceremonies at the Common Riding.

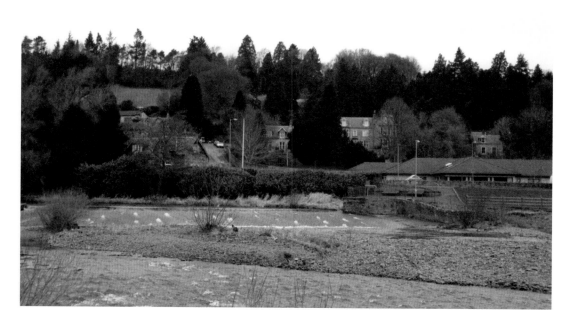

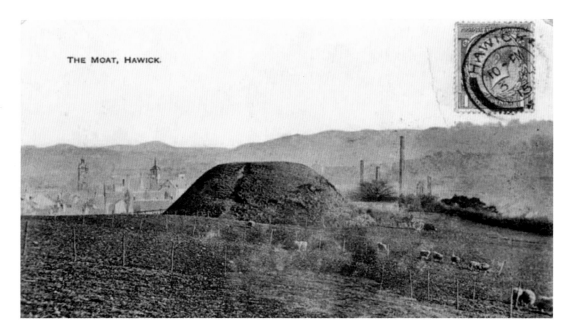

THE MOAT, HAWICK.

The Moat, 1915 and 2014

The Moat is an artificial earthen cone and one of Hawick's oldest inhabited sites. In 1911, it passed into the Hawick Common Good. A survey of the site was conducted a year later, which uncovered a flat-bottomed ditch, numerous shards of pottery, and a Henry II silver penny – all of which suggested a twelfth-century site. It is said to have been a motte-and-bailey castle. On top of the mound would have been a wooden tower and around the base a small settlement of houses and farm buildings. The area surrounding the Moat is today a small park, complete with a replica siege catapult.

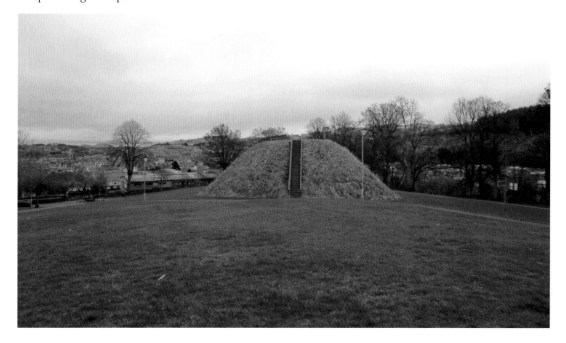

Birthplace of Old Mortality, 1984 and 2013
The land here was feued by Simon of
Routledge (Hawick's first known Burgess)
in 1433 and sold to Sir Walter Scott of
Buccleuch in 1448. It was said to extend as
far as the Smaile Burn – the feature after
which the Burnflat Brae is named. Until the
early twentieth century, the cottages were
separated from those at the top of the Loan
by around a quarter of a mile of fields. Most
were demolished by 1939, with only Paterson's
birthplace being preserved. This was also later
demolished following a fire in 1991. Housing to
the west of Burnflat Brae was named Paterson
Gardens in 2006, in honour of 'Old Mortality'
Robert Paterson, who famously tended to the
graves of Covenanters.

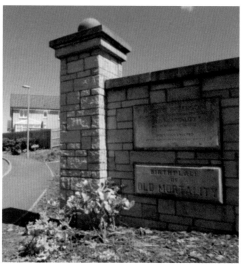

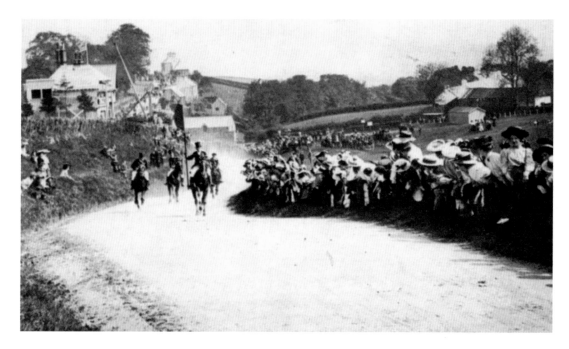

Nipknowes, 1910 and 2014

The Chase up the Nipknowes is an integral part of the annual Common Riding. Riders are split – the Acting Father heads up the hill with the married supporters, then the Cornet, complete with the Hexham Banner, follows with the unmarried supporters. Hawick Golf Club (right) was founded in 1877 by Robert Purdom, Charles Taylor and John Manuel. Located on the Vertish Hill, it can count Nick Faldo (who holds the professional course record of sixty-four), Colin Montgomerie and Tony Jacklin as honorary members. The current eighteen-hole course, designed with help from James Braid, is a par 68.

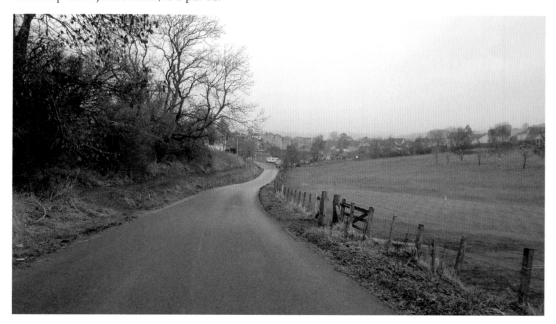

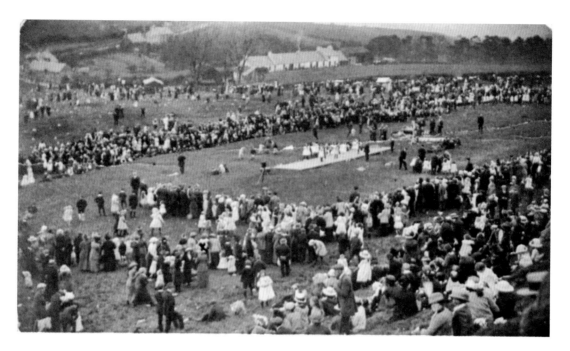

The Vertish, 1910 and 2014

The Vertish Hill Sports is held annually on a specially levelled part of the Vertish Hill. It includes races for primary school children, preceded by a procession from the Evergreen Hall (formerly from the Buccleuch Memorial building) to the Vertish. Started in 1882 as a kite-flying contest for boys under the age of sixteen, other games and races were soon added. The precise day on which the games are held varies each year, but it usually lands on a Saturday near the end of June.

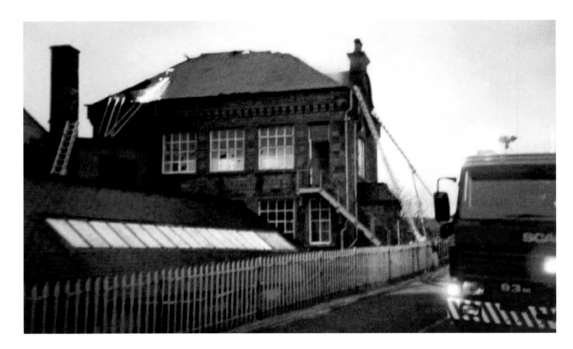

Wellogate Brae, 1995 and 2014

Originally located in Underdamside as part of William Watson & Sons, the mill was taken over by George Hogg in 1863. Around 1885, the company moved to a plot of land between Mill Path and the Waverley Line, formerly the premises of Robert Ewen. The taller block was built on the north side of the property in 1887; an imposing Victorian building with large windows, ornamental corbels near the rood level and an ogee-headed gable on the side facing the road. The factory became derelict in the 1980s, and was ravaged by fire twice, in June 1994 (above photograph) and in 1999. The buildings were demolished in 2000 and the site is now occupied by housing.

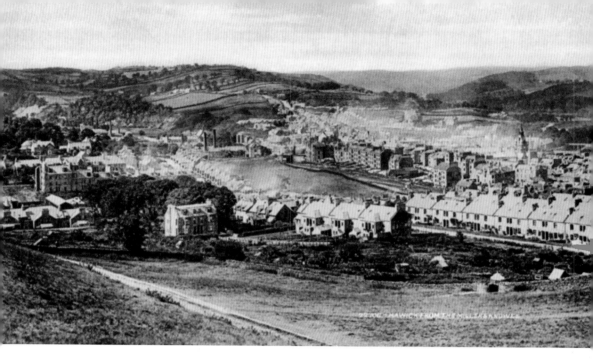

Loch Park, *c.* 1902 and 2014

In the middle distance of these photographs is Loch Park, an area named after a small pond and grazing land. It was drained by the Burgh Council in 1835 to rid the area of its pestilential vapours. During the latter half of the nineteenth century, the land was used as an auction ring by Oliver & Sons, before a railway maintenance yard and sidings were built in 1921. With the impending closure of the Waverley Line, the site was converted to an industrial estate for small businesses in 1968. Loch Park Printworks closed in 2000, and the last of Hawick's newspapers is now printed in Newcastle.

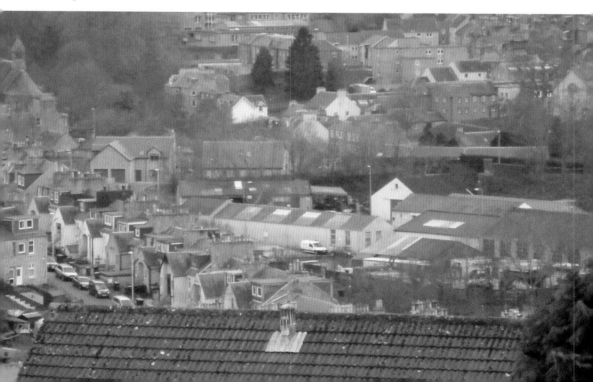

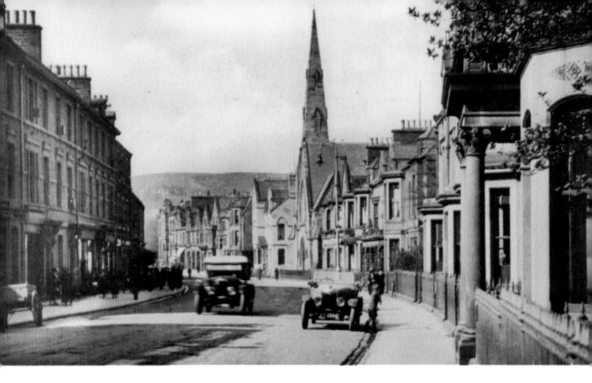

North Bridge Street, 1920s and 2014

Before this road was developed, the area had been in use as Dickson's Nurseries. The northern end was built largely between 1899 and 1900, with Nos 41 to 49 designed by prominent local architect James Pearson Alison. No. 43 was Jed Murray's studio and No. 45 was Alison's own house and office – the studio is now home to The Border Club. It is arguably one of Hawick's most important streets in terms of architecture – with the Pru, former post office, Elm House Hotel, Baptist kirk and Hawick's Carnegie Library sited here, not to mention the now demolished Buccleuch Memorial building and the St Andrew's United Free church (above, centre).

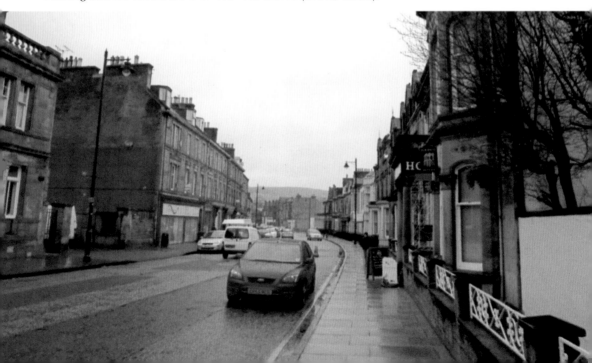

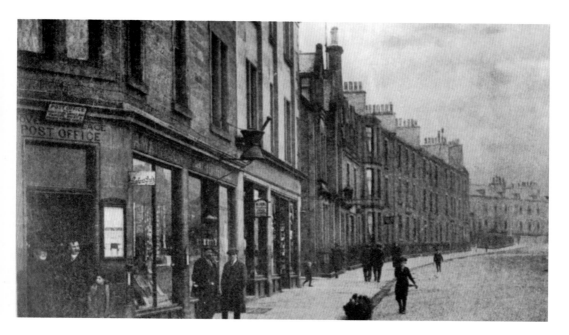

Dovemount Place, *c.* 1906 and 2014

This area of Hawick was previously known as Easter Howlands – an eastern hollow of the Langlands estate. The road through Dovemount was built in 1832 to connect the east end of Hawick with Wilton, across the new North Bridge, along with a toll house. Dovemount Toll was one of four major toll houses across the town. A plaque commemorating the site lies near to the leisure centre. The StationBuildings (left) were erected in 1871 overlooking the town's former railway station. In those days, it had direct competition from the nearby Railway Hotel at No. 6 Wilton Place (now No. 14 Princes Street).

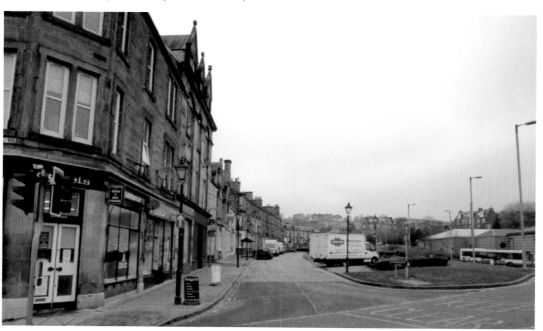

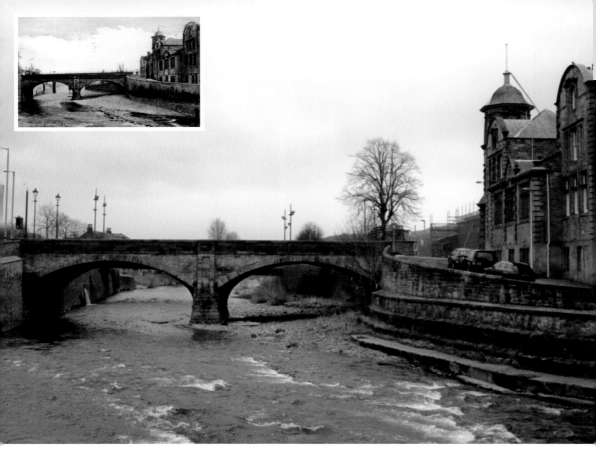

North Bridge and Carnegie Free Library, 1939 and 2014
The North Bridge was built in 1832 by John and Thomas Smith of Darnick, and was funded by turnpike trustees. In 1882, it was widened, with the corrugated iron parapets removed and the pavement width added to each arch. Originally, it had four arches, with two allowing carts to pass at the riverside. These were filled around 1890, when the river banks were built up to street level. It was closed to road traffic in 2000, when the Waverley Bridge was opened to carry the main southbound A7. Hawick's Free Library was built with a gift of £10,000 from Andrew Carnegie and opened in 1904 by Carnegie himself.

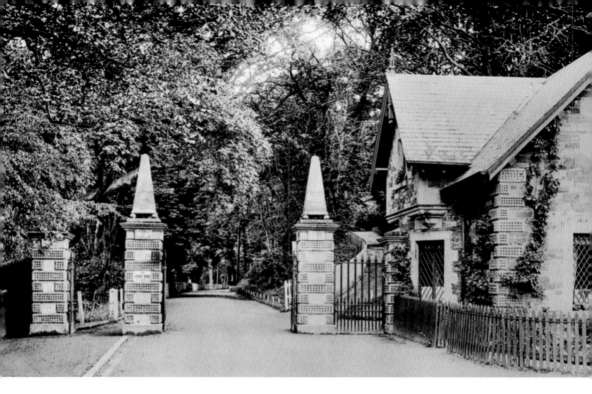

Wilton Lodge Park's Gates and Lodge, *c.* 1902 and 2014

The gate house to Wilton Lodge was built some time before 1863, at the end of the Avenue – the estate road commissioned by Wilton Lodge owner James Anderson in 1810. A western extension was added around 1917. The lodge and adjacent gate piers were listed as Category C structures by Historic Scotland in 2008, being distinctive for their decorative dimpled quoins. A five-year restoration plan of Wilton Lodge Park was announced in December 2012, which includes a plan to restore the gates to their former glory.

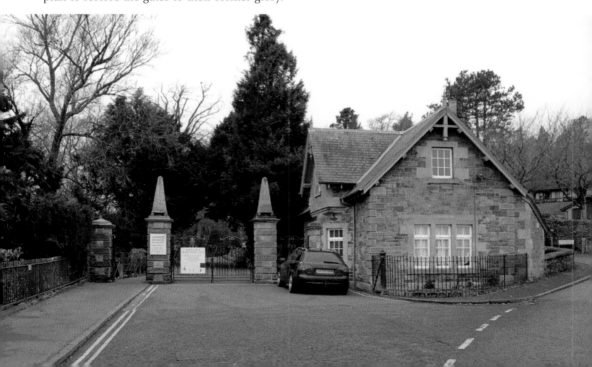

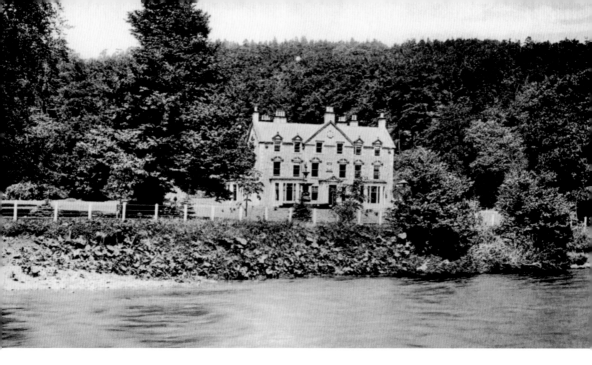

Wilton Lodge, *c.* 1902, and Wilton Lodge Park, 2014
Formerly known as Langlands, the land here once occupied the western half of Wilton parish. The estate diminished in size during the eighteenth century, and was sold off entirely in 1783. In 1868, the remaining mansion house was renamed 'Wilton Lodge' and was for a time utilised as a private school. In 1889, Hawick Burgh Council bought the estate at a cost of £14,000, to form a public park, with the house being converted into Hawick's permanent museum in 1910. Extensive renovations were carried out in 1959 to showcase local exhibits, and in 1975 the Scott Gallery extension was added.

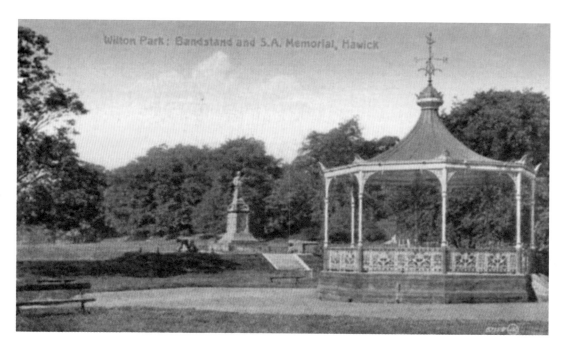

Wilton Park: Bandstand and S.A. Memorial, Hawick

Wilton Lodge Park, 1910 and 2014

Situated on an ornamental platform, the park bandstand was built in the early years of Burgh ownership. The base was turned into a paddling pool around 1970 and, after only a few years, became a flower bed. It is hoped that Heritage Lottery funding, secured in 2012, will be used to restore the former bandstand. Hawick's Boer War memorial was unveiled in August 1903 by Lord Roberts, then commander in-chief of the British Army. The cannons that originally flanked the monument were removed for scrap metal in 1940.

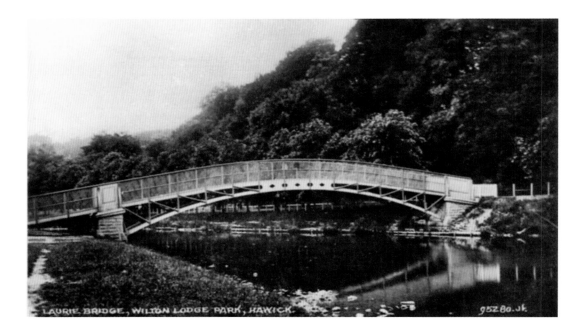

Laurie Bridge, Wilton Lodge Park, 1940s and 2014

Spanning the River Teviot at Spetchman's Haugh, this footbridge is named after Walter Laurie, who bequeathed the money for its construction. It was built in 1924 and opened by the future King Edward VII in December of that year. This patch of land had previously been used in the period 1812–14, for the morning roll call of French prisoners of war. Many decades earlier as a councillor, Charles Wilson (who jointly funded the town's first public baths in 1912) had suggested building a bridge at the Spetch. His plans were met with plain indifference.

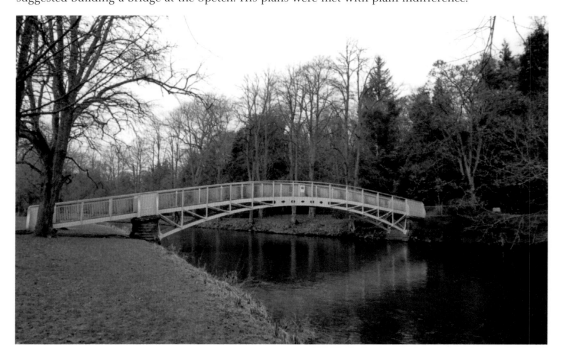

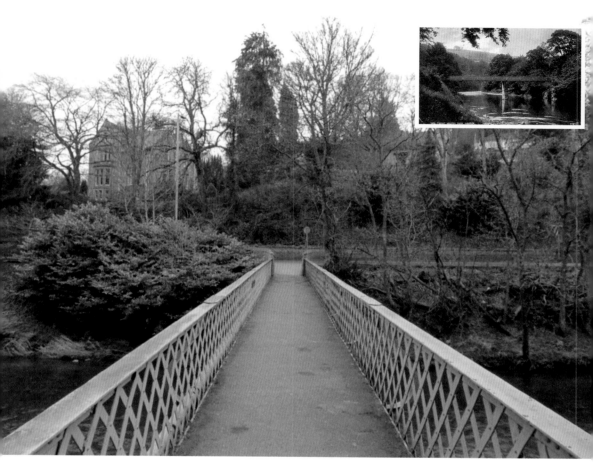

Langlands Bridge, Wilton Lodge Park, 1943 and 2014

Langlands Bridge, situated off Buccleuch Road at the western end of Wilton Lodge Park, was erected in 1893. Built by local firm Craik & Chisholm, it marks the former boundary of the Burgh of Hawick. Nearby lies the MacNee memorial fountain. This ornate grey granite drinking fountain was erected by public subscription in 1906, in memory of George Fraser MacNee. He died from an accidental gunshot wound, while out shooting rabbits near Corstorphine.

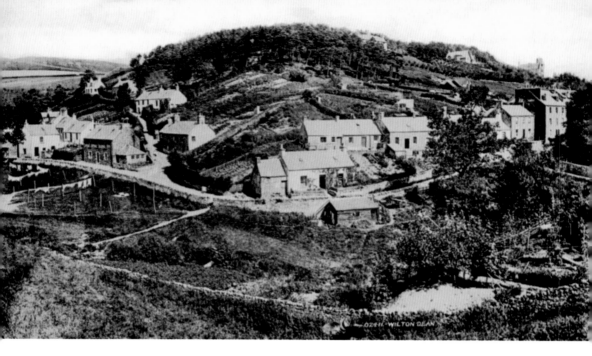

Wilton Dean, *c.* 1912 and 2014

A settlement on the banks of the Cala Burn, this area of Hawick once constituted a separate community within Wilton parish. It was first settled during the fifteenth century, and was formerly known as Langlands Dean. During the early nineteenth century, a stocking-making business was established at the Dean Spinning Mill, near the foot of the burn. The factory did not last into the twentieth century and the old millpond was drained to form a drying green and play. The name of the village only officially changed to Wilton Dean in 1861. The community school, which was established in the 1870s, closed in 1937.

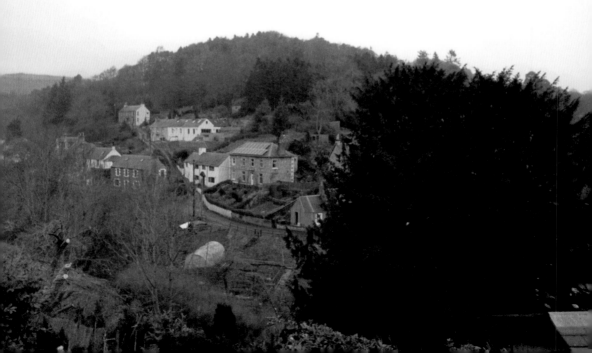

Buccleuch Plant Nursery

Buccleuch plant nursery (above, centre) was founded by John Forbes in 1879, on land rented from the Duke of Buccleuch. For a while, it was the largest grower of Penstemons (Beard Tongues) in the world, offering 550 varieties in 1900. The business was renamed in 1907 after receiving a royal warrant, but it was still known locally as 'Forbes Nurseries.' The firm closed in 1968. Stonefield housing estate (below) was built in its place from 1971.

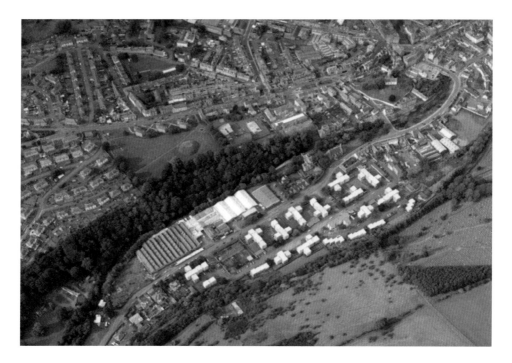

Stonefield, 2009 and 2014

This aerial shot shows the distinctive layout of mid-rise housing blocks on the Stonefield estate. A new road south out of the town was created in 1800, as one of the first expansions beyond the medieval burgh. The original buildings were a row of two-storey terraces, only a few of which retain their original details. By the 1820s, Stonefield was a thriving industrial suburb with flour mills, a tannery, woollen manufacturers and a brewery. A dedicated mill lade was created in 1857, stretching from Mill Path to Lynnwood, and various houses were erected on the east side of the road by the end of the century. Today, there is an ongoing £10-million redevelopment of the area, which will see the creation of affordable housing.

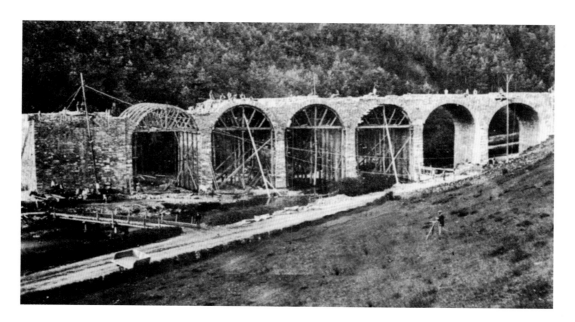

The Scud, 1860 and 2014

At a point known locally as 'the Scud', there stood a majestic six-arch viaduct over the Slitrig Water. Built in 1860 and seen under construction above, and variously called the Six Arch Brig, Crowbyres, Slitrig or Lynnwood Viaduct, it was demolished in 1982 after local children were frequently caught throwing ballast onto the road below. A short section of parapet wall and a railing is all that remains today, with the trackbed used as a walking and bridle path. A set of wooden steps were built to access the path in 2009.

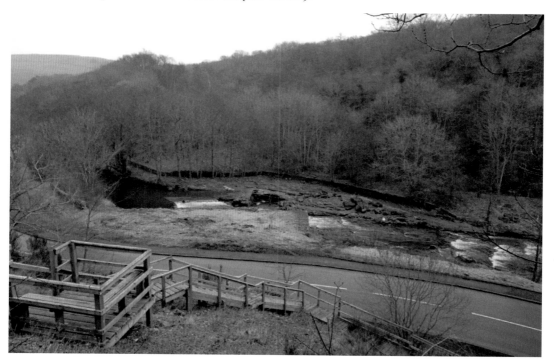

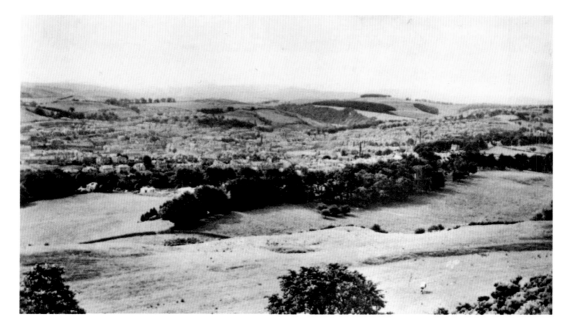

Galalaw, 1940s and 2013

The land surrounding Galalaw has been farmed since at least the fifteenth century, being owned by a branch of the Scott family from 1494 until 1762. During the nineteenth century, the current farmhouse was built and the area was used for fox hunting. In 1856, to celebrate the end of the Crimean War, Galalaw was set ablaze; the vegetation took decades to recover. In July 1953, the Ordnance Survey built a trig point on Galalaw Summit for measurements of distance and mapping in the days before GPS technology. Roxburgh District Council bought 144 acres of farmland here in 1992, and work began on Galalaw Business Park in September 1994.

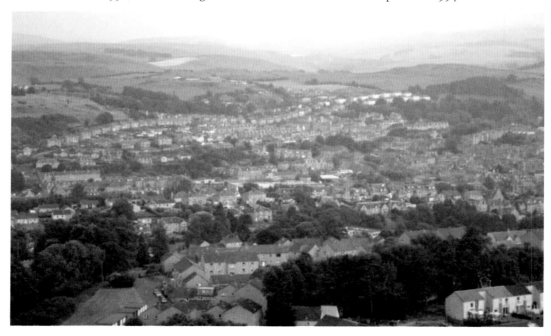

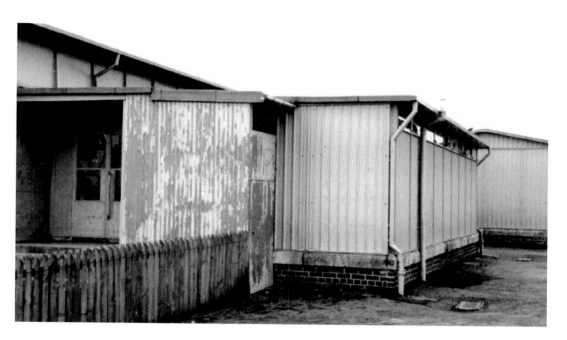

Burnfoot School, 1995 and 2014

Burnfoot Infant School, pictured above, also contained a nursery, the school nurse's room and several classrooms. The adjacent hut contained a small gym hall. The 'big schuil' (Burnfoot Primary) on Kenilworth Avenue was built in 1952 to serve the newly built housing scheme. It was refurbished extensively in 1995 and renamed Burnfoot Community School. Around the same time, the old infant school was demolished. The empty grounds are now used as a car park and by dog walkers. The Burnfoot Carnival was first held by the Hawick Residents Association in 1969. It was revived in 2007 by volunteers, and is now held annually on the site of the old infants school.

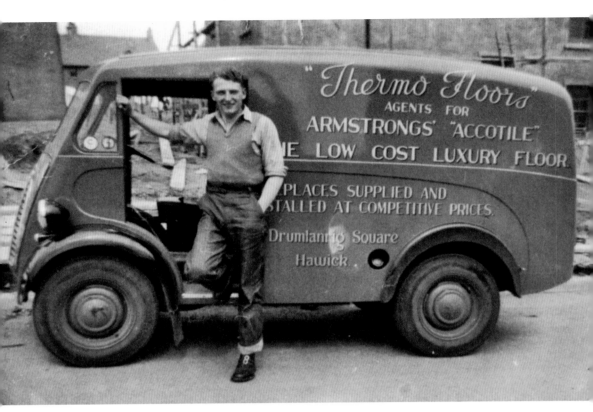

Fraser Avenue, 1953 and 2013
'Burnfit' is the largest housing estate in the Scottish Borders, situated on the banks or foot of the Boonraw Burn. In 1947, the town council purchased the adjoining lands of Burnfoot and Burnhead, which almost doubled the size of Hawick. Work began on the new estate in 1949, when Burnfoot Road was realigned and new streets were created right across the estate until 1958. Here we can see Ronnie Bald taking a breather from construction work at Fraser Avenue in 1953. Below is a view of the Burnfoot Carnival procession down the same street, sixty years later.

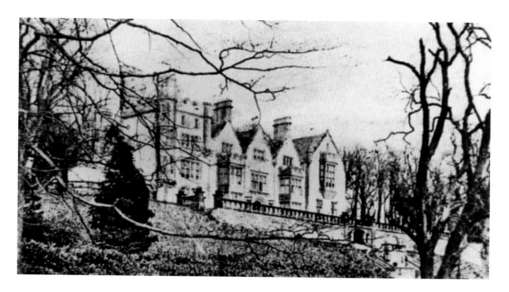

Stirches, 1950s and 2012

The name of this area is a corruption of the Old English 'stirk' (a thicket or bush), and 'shaw' (a dwelling by the wood). The current housing estate, built between 1973 and 1977, and country house take their name from the anglicised form 'Stirches.' Stirches House was constructed around 1503 by the Chisholm family, although any identifiable medieval masonry has since been destroyed by later renovations. Ownership of the house passed to Mr Blinkhorn of Richardson Mill in the 1800s, to which he added a croquet lawn, tennis court and quarters for more than 100 servants and grounds staff. The Augustinian Order of Sisters took possession of the house in 1926 and opened a convent and geriatric home. The last resident nuns left in 2004 and today it is a care home for the elderly.

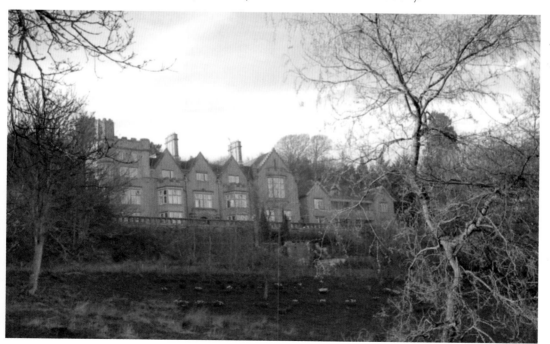

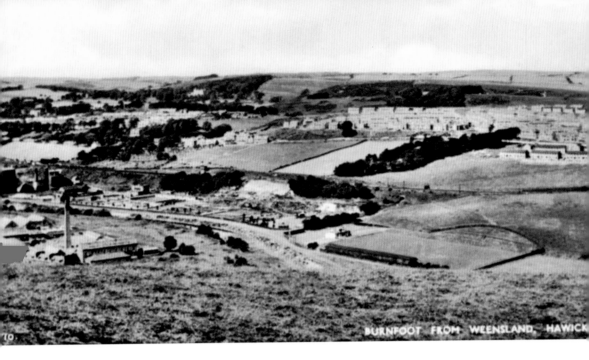

Burnfoot from Weensland, 1949 and 2013

Hawick is a dyed-in-the-wool rugby town. From the high school and Hawick Albion to the PSA and Hawick Wanderers, to Hawick Harlequins, Hawick Linden, the Trades and Hawick YM, and the senior Hawick team, rugby plays an integral role in the life of many a Teri. Mansfield Park (above, right of centre) has been home to the 'Greens' since 1888. There has been a mill at Weensland (above, left of centre) since at least 1717. By the 1890s, there were three separate tweed companies operating in Weensland: George McLeod & Son (which only lasted a year), Scoon & Barrie and the Weensland Spinning Co. Following the closure of the mill complex in 1991, the buildings were ravaged by fire several times. Today, the Category C listed buildings lie empty.

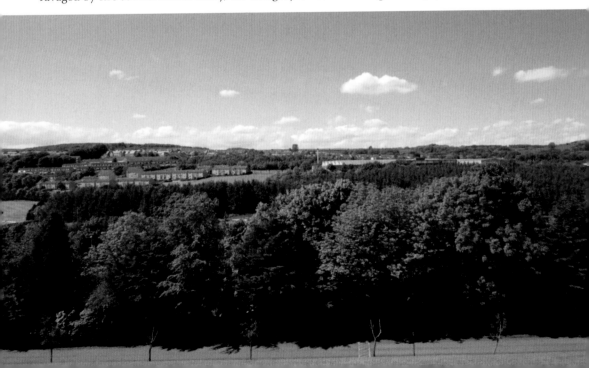

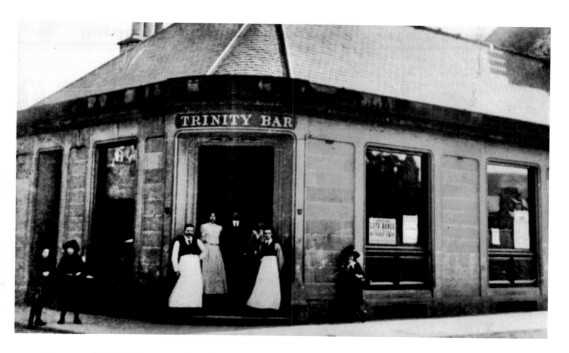

Corner of Duke Street and Noble Place, 1904 and 2014

This area of Hawick was originally known as 'Soutralands', after the Soutra Croft that stood here – a holding of the House of the Holy Trinity. This link was made at some point in the fourteenth century, when a church complex comprising a hospital and a friary was established at Soutra Aisle, 40 miles north of Hawick (just off the route of the current A68). The area became known as 'Trinitylands' by the 1590s, and today much of the area retains the Trinity name, which is best seen in the name of the bar that occupies the corner of Duke Street and Noble Place. The current building was erected during the 1890s and was known for a time as Mack's Bar. It was extensively refurbished in the 1990s.

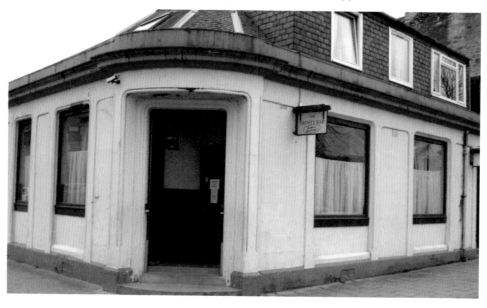

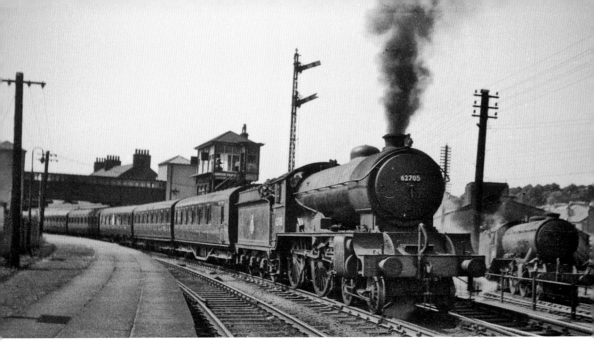

Hawick Railway Station, 1959, and Teviotdale Leisure Centre, 2014
Class D49 locomotive *Lanarkshire* heads the noon service to Edinburgh in July 1959. Hawick Railway Station opened as the terminus of the Edinburgh & Hawick Railway in November 1849. The extension of the route south to Carlisle paved the way for the closure of the original station in 1862. This was replaced by a new building (above), which was constructed on a curved route to allow for access south across the River Teviot. The final passenger service left Hawick on 6 January 1969 and the station was demolished in 1974. The site was purchased by Roxburgh District Council and levelled for a new Leisure Centre, which opened in June 1982 (below).

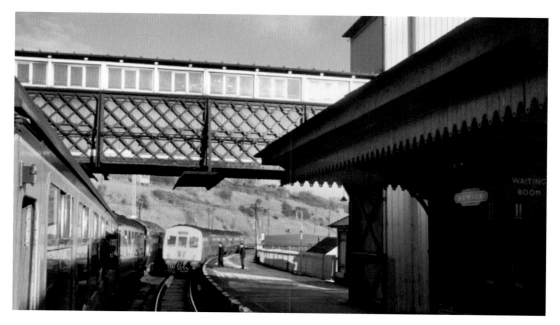

Hawick Railway Station, 1969, and Teviotdale Leisure Centre, 2014
A southbound DMU pulls into Hawick on the last day of passenger services on the Waverley Route (5 January 1969). Proposals to close large sections of the line were green-lighted by Transport Minister Richard Marsh (an advocate of roads) in July 1968 and the final service exited Hawick the morning after the above photograph was taken. During 1974, the engine shed, goods yard, loading docks, water towers and signal boxes were demolished. The platforms and Teviot Viaduct lasted just a little longer and were demolished in September 1975. Today a car park occupies the northern end of the former station.

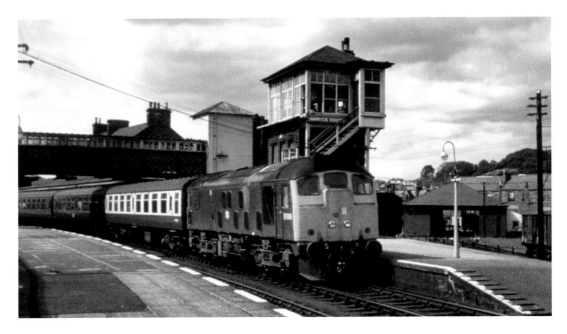

Hawick Railway Station, 1968, and Teviotdale Leisure Centre, 2014

D5116 at Hawick in 1968, with a good view of the goods yard in the background. One of the few remaining relics of the railway is the edge of a loading bay that now forms part of the landscaped Waverley Path. This dates to the 1890s, when the goods yard was extended north. Hawick's original station was situated 81 metres west of its replacement (above) and was latterly used as a goods depot. Freight traffic continued to the Lady Victoria Pit until 28 April 1969, and the yard was largely demolished during 1974.

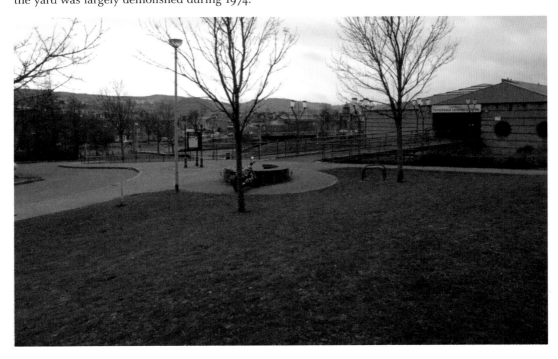

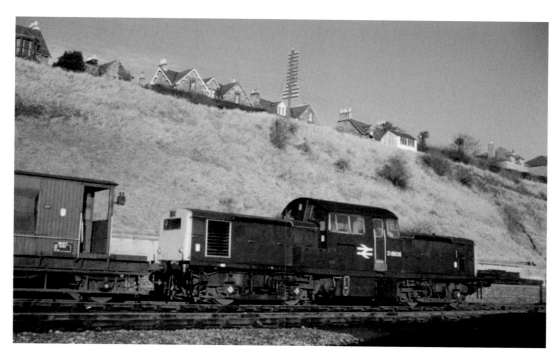

Hawick Railway Station, 1969, and Teviotdale Leisure Centre, 2014

Hawick pilot D8606 sits near the locomotive shed in January 1969. This Clayton Type 1 was called south to check the Waverley Route ahead of the final passenger service on the night of the 5th/6th. The journey was memorable for protests at both Hawick and Newcastleton, a large police presence and the arrest, negotiation and release of a parish minister! Today this section of the trackbed is a footpath that connects Burnfoot to Mansfield. A £27,000 skate park was opened a few hundred yards east of the former station in 2001, after talks between The Small Wheels Association and the Scottish Borders Council.

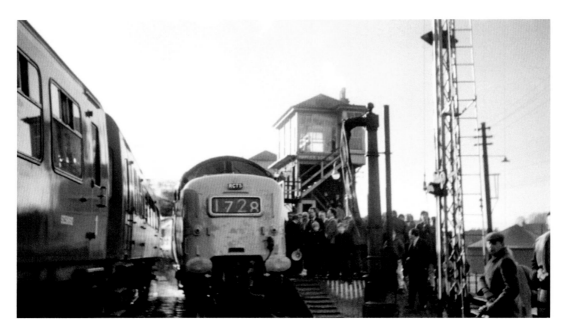

Hawick Railway Station, 1969, and Teviotdale Leisure Centre, 2014
A Railway Correspondence & Travel Society tour calls into Hawick – en-route from Leeds to
Edinburgh – during the final weekend of passenger services on the Waverley Route. Forty-four
years later and how the landscape has changed. Roxburgh District Council levelled the site
in the late 1970s in preparation to replace the town's ageing swimming pool on Bath Street.
The Teviotdale Leisure Centre and appropriately named Waverley Pool opened in June 1982,
to a design by Faulkner-Brown, Hendy & Stonor of Newcastle. It is the currently the largest
recreational amenity in the Scottish Borders.

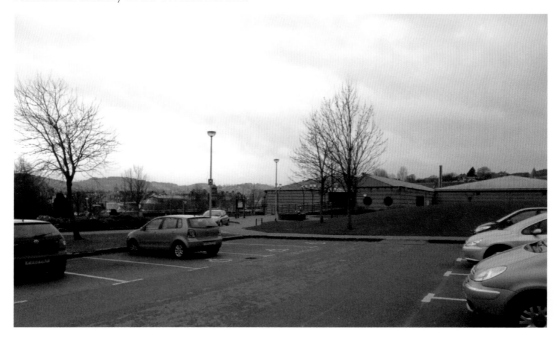

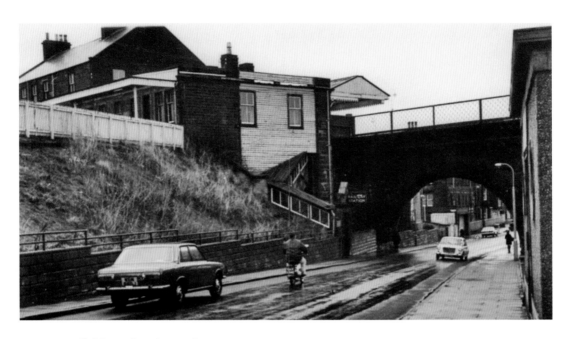

Mansfield Road, 1960s and 2014

Here we can see the exterior of Hawick station and the underpass on Mansfield Road. The six-arch Teviot Viaduct (above) was opened on 23 June 1862. It was unusual in that it curved to meet the southern approach of the Waverley Route, and the re-sited Hawick Station. Passing over the River Teviot at a height of 42 feet, the viaduct had extended wooden boards which hung over the platforms. It was demolished in September 1975, by two controlled explosions. This road was heavily landscaped with the opening of the nearby Waverley Bridhe in 2000.

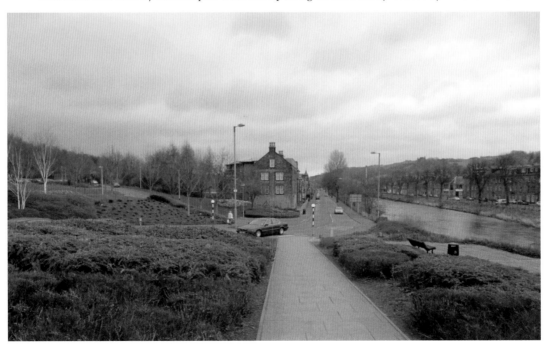

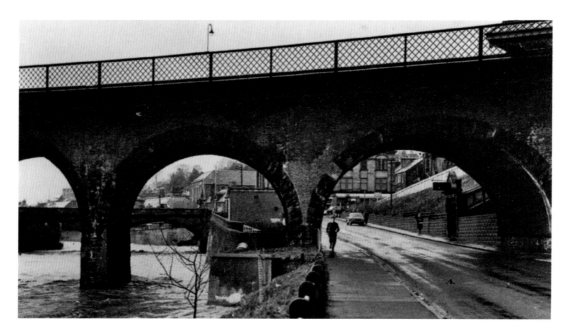

Mansfield Road, 1960s and 2014

There have been some real changes in the years since the above photograph was taken. The Teviot Viaduct has made way for the Waverley Bridge (below). Opened in 2001 as part of a traffic relief scheme, this serves as a replacement for the ageing North Bridge. Just out of shot through the middle arch was St Margaret's and Wilton South kirk. Built in 1894 and designed by J. P. Alison, this was an elegant red sandstone structure that incorporated stone from Longtown Quarries. The church closed in 1987, and was demolished in 2001 after it became unstable and unsafe.

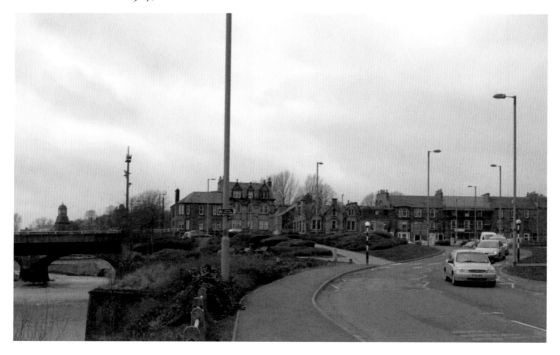

Mart Street Embankment, 1970 and 2014

The Up line of the Hawick section of the Waverley Route was removed in February 1970, with the Down line following in 1971. Indeed, the last recovery train passed through the station on 18 April 1971 (much later than most people think and over two years after the station closed). The main building was later used by the Royal Mail for deliveries and storage for a short period after its closure. Mart Street embankment was removed in June 1976, and today Mart Street occupies the route taken by the demolition convoy (right).

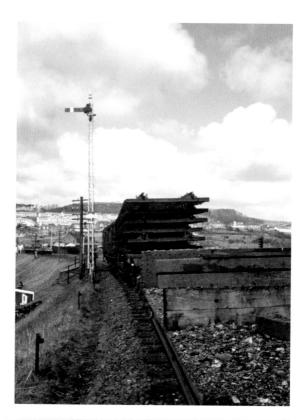

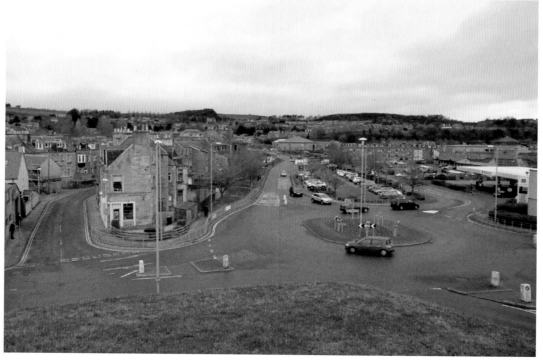

73

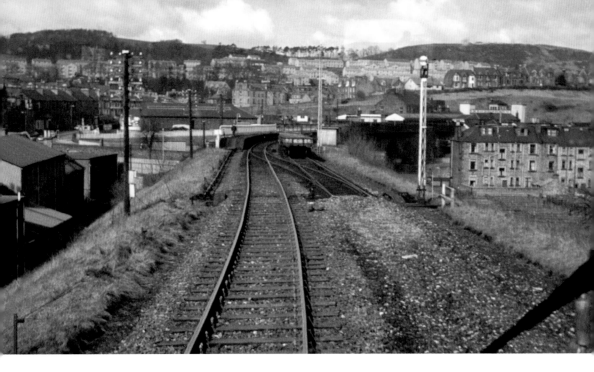

Mart Street Embankment, 1970 and 2014

These days it is not possible to command a similar view, due to the removal of the railway and the embankment. The Campaign for Borders Rail (who fully support the extension of the Borders Railway to Hawick and beyond) have suggested that a long, H-shaped bridge may be needed to carry any future railway over the Teviot. This would allow the trackbed to match the height of the former embankment at this point.

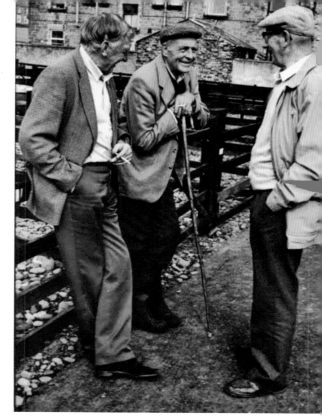

Oliver & Son Auction Mart, *c.* **1960s, and Auction Mart (Site of), 2013**
Some elderly gents stop for a 'wee blether' at the Duke Street end of the old Auction Mart. Built in 1883 on an area of land then known as 'Lawrie's Denn', this was one of the oldest established auction market premises in Scotland. Operated and owned by Andrew Oliver & Son, a family firm of auctioneers, their livestock market first took place at the Common Haugh in 1817. It moved to various locations within Hawick, including Bourtree Place and Loch Park, until the construction of a more permanent site at Trinity in 1883. Andrew Oliver & Son are credited with originating the livestock auction mart system in Britain in 1847. The photographed area is now a car park for the adjacent Morrisons supermarket.

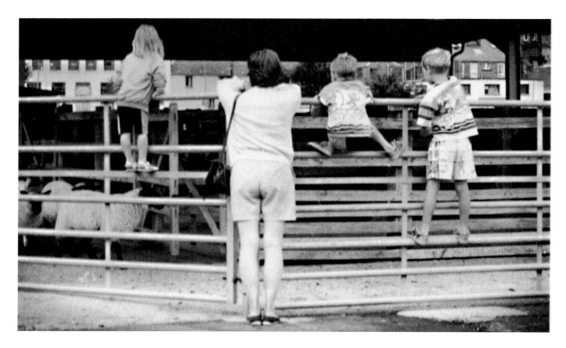

Oliver & Son Auction Mart, 1980s, and Mart Street, 2014

A family observe some local livestock at the Auction Mart, with the Territorial Army Hall just visible in the background. Mart Street was opened in 1978, following the removal of a large railway embankment, which carried the Waverley line to Hawick station. The street was named in homage to the former livestock premises and is today the location of the town's main bus stances. Buses were originally stationed at a two-storey depot on Dovecote Street, which was opened by the Scottish Motor Traction group in the 1930s. It closed in April 2002 and the local offices were transferred to Oliver Place.

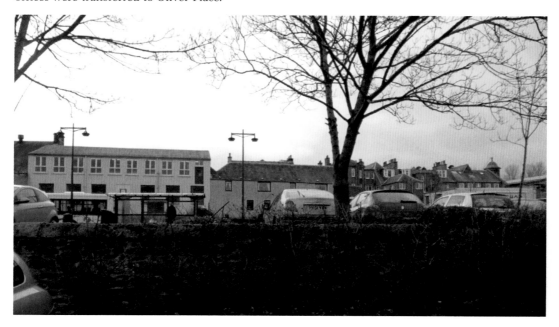

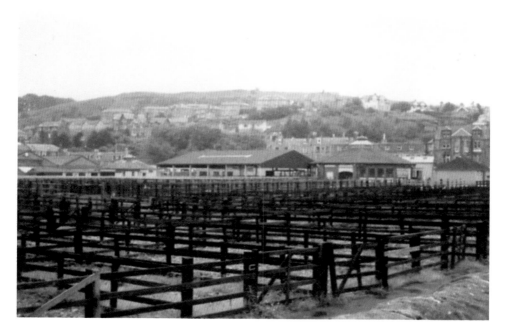

Auction Mart, 1980s, and Morrisons Supermarket, 2014

The main building of the Mart was an octagonal-roofed structure at the southern end of the sheep pens (above, right), where the sales were conducted. A memorial clock to Andrew Rutherford Oliver, partner in the business, was the most prominent feature of this building. Oliver Park at Weensland is also named after him. The auction site was fully closed in 1992 and the land developed as the largest Safeway supermarket in the Borders. Opened in 1993, it became a Morrisons in 2005 following the group's £3 billion takeover of Safeway.

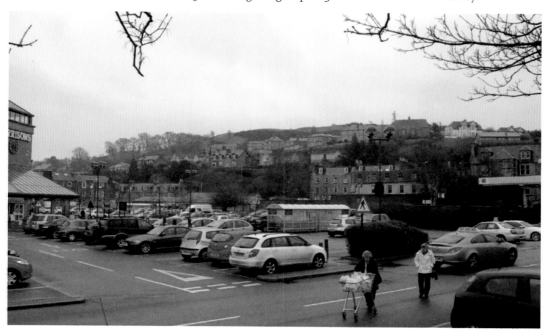

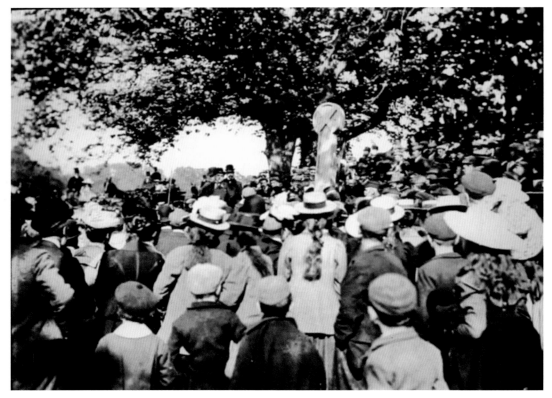

Lest We Forget Monument, 1901 and 2014
The Lest We Forget Monument, better known as the Hornshole Memorial, was unveiled in 1901. This was erected in tribute to the bravery of Hawick's young men, or 'Callants', during the Hornshole Skirmish of 1514. It is scheduled to be replaced at a cost of £3,000 in time for the 2014 quincentennial celebrations. Built on a small piece of land gifted by Capt. Palmer-Douglas of Cavers, this was paid for with money left over from subscriptions to the *Return to Hawick* painting, which depicts this historical event. It was sculpted by Robert Robson and unveiled by Bailie Lawson's daughter on the Saturday before Common Riding week, with 'Jed' Murray writing a special poem for the occasion.

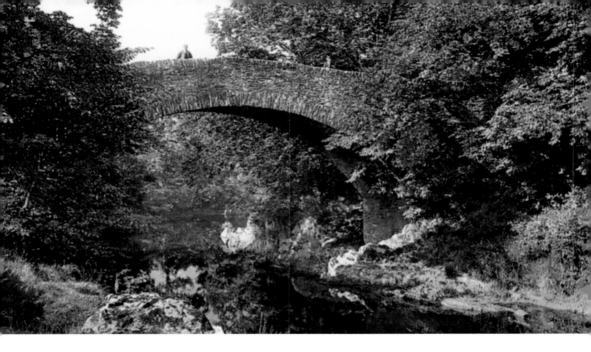

Hornshole Bridge, c. 1900 and 2011
Hornshole Bridge carries an unclassified road over the River Teviot and replaced an earlier ford. It was built between 1772 and 1774 with money from neighbouring landowners, assisted by a grant from the Road Trustees. Construction was overseen by Adam Scott and John Pott, although Scott retired following an accident, when framework used to build the arch collapsed. Pott died soon after its completion, as the result of an injury suffered when removing scaffolding planks from the bridge. It was listed as a Category C structure by Historic Scotland in November 2007.

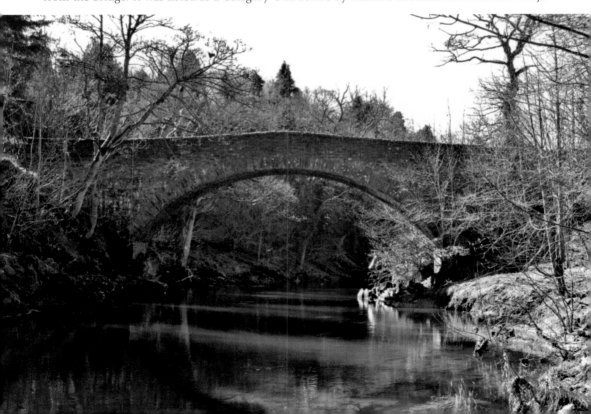

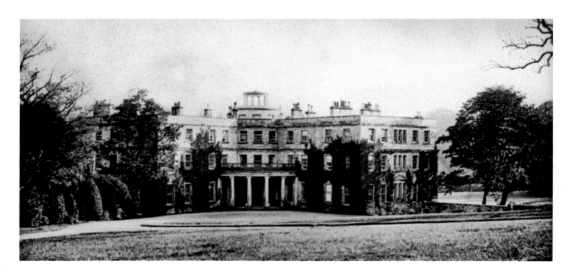

Minto House, 1910 and 1980s

Minto House, or 'Minti', was a seat of the Elliot family for over two centuries. The original house contained the remains of a Border Peel Tower, which was destroyed in 1545. It was substantially remodelled by 1743 to a plan by William Adam, although the design we see above was an 1837 alteration by William Playfair. At that same time, the nearby village was moved so that it could not be seen from the windows of the mansion. It was later used in the war effort, then rented as a private girls' school, Craigmount, until 1962. A period of neglect and dereliction followed, as seen in the photograph below. The house was demolished in August 1992 amid controversy, despite being relisted as a Category A structure the previous year. This became known as the 'Minto Debacle,' which has since influenced building preservation throughout Scotland. Today, the estate is home to Minto Golf Club, opened in the 1920s.

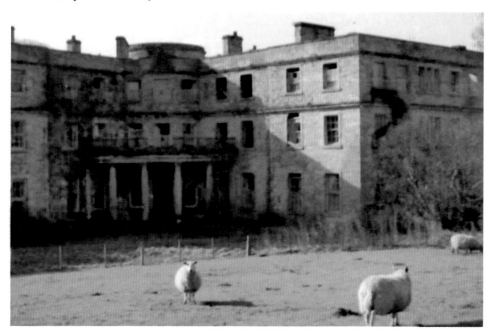

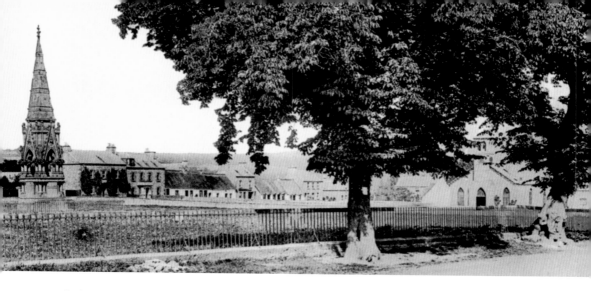

Denholm Green, 1902 and 2013

Hawick has enjoyed a long affinity with Denholm Green. Two fairs were established here by the Laird of Cavers in 1696, the Summer Fair taking place in early June and the Mart Fair in November. He traditionally held the right to collect dues on all transactions. The Mart Fair was where families would take in their salted winter provisions. In 1835, the Laird, wishing to 'improve and beautify' the green, encouraged the village feuars to clean it up in exchange for extra land behind their homes. In the early twentieth century, local auctioneers Scott & Rutherfords ran a second auction from Denholm Green to supplement their Hawick site. Today, the Cornet, the Principals and followers ride out to Denholm during the Common Riding, at the behest of the Denholm Feuars' and Householders' Council. In the middle of the green stands Leyden's Monument, which was erected in honour of Dr John Leyden (1775–1811), poet, antiquarian and orientalist, who was born in Denholm.

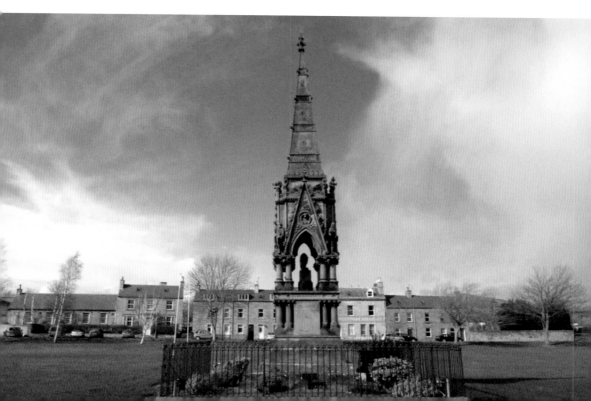

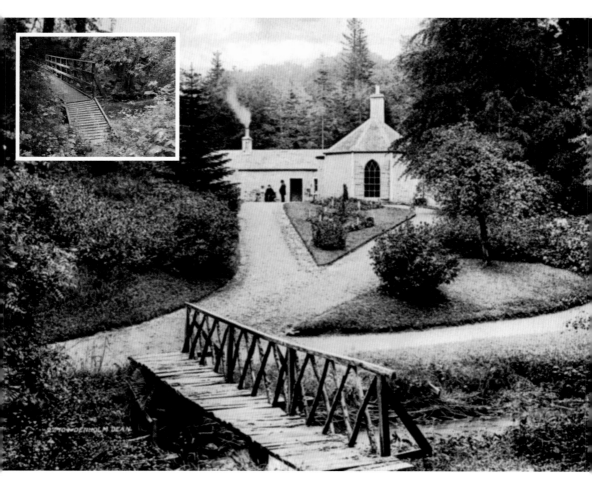

Denholm Dean, 1902, and Dean Burn Footbridge, 2012

The lands beside the Dean Burn have been occupied since at least 1375. Denholm Dean is first mentioned in 1511, as part of the nearby lands of the Barony of Cavers, and for a long time it remained the property of the Laird of Cavers, who created a pleasure garden that became popular with locals in Victorian times. The cottage (above) was built in around 1730 as a hunting lodge, becoming a tea pavilion in the nineteenth century. The resident Wylie family felled timber here for a nearby sawmill on the Dean Burn until 1948, after which it lay derelict. Its roofing was removed in the early 1950s and today the remains of the cottage can be seen on the banks of the burn.

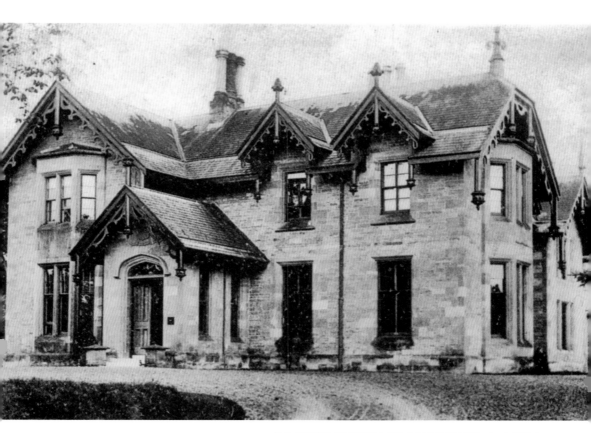

**Knowesouth House, Early 1900s,
and Knowesouth Care Home, 2013**
Knowesouth House, situated between
Hawick and Jedburgh, was held in the
Rutherford family for many generations.
Built in the late eighteenth century,
it was expanded in its current design
during the early nineteenth century.
With the addition of the Oakbank
extension in 2007, it is now managed
by Guardian Care as a home for the
elderly. Knowesouth hamlet can trace
its history even further back to the
late eleventh century, as confirmed by
surveys of earthworks found at the
nearby Knowesouth Burn. The Dovecot
in the grounds is a Grade A listed
structure, and is unique in that it has
been protected ahead of the house.

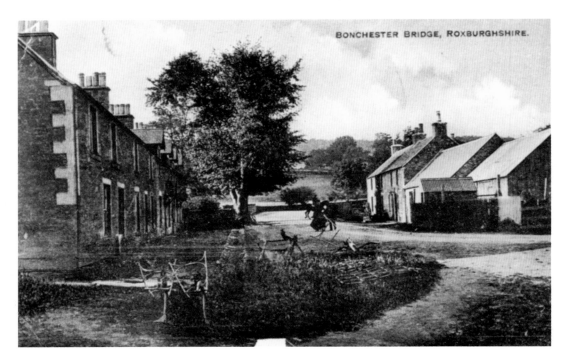

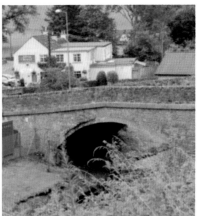

Bonchester Bridge, Early 1900s and 2012
Once occupied by the Romans under the name Bona
Castra, or 'good camp', Bonchester today is a hamlet
that lies on the banks of the Rule Water, 6 miles out of
Hawick. The bridge itself was constructed in the early
years of the nineteenth century as part of the new toll
road from Hawick to the Carter Bar. The village's Horse
& Hound Inn was established in 1701 as a staging
post and coaching inn, although the original building
was demolished and rebuilt by James Chisholme in
the early nineteenth century. In 1899, prolific Hawick
architect J. P. Alison designed Bonchester's William
Laidlaw Memorial Hall. Its erection was funded by Sir
Robert Laidlaw in memory of his son William, who
died in infancy, and his father William.

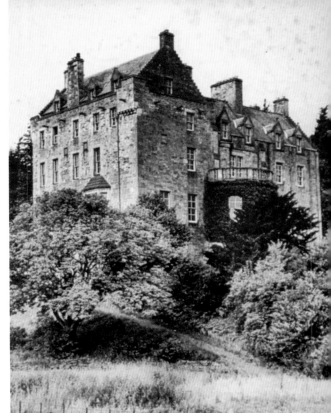

Cavers House, *c.* 1950 and 2013
Cavers was built during the twelfth century when the estate was still owned by the Baliols. It was then held by the Douglases for over six centuries. This structure is sometimes referred to as the Warden's Tower (and partly survives on the south-east side). It suffered much during the time of the Border Reivers and was almost burned to the ground in 1542. King James VI of Scotland stayed at the house on a return visit to his kingdom in 1617. After the Second World War, the condition of the house deteriorated and it was mostly demolished in 1953 during an Army explosives exercise. The solid walls of the older keep survived the blasts and today these ruins lies in splendid isolation in private woodland.

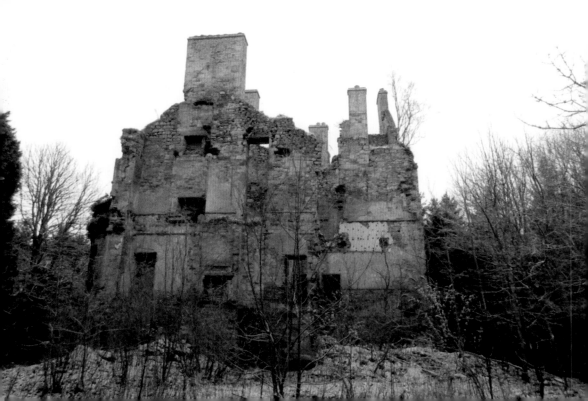

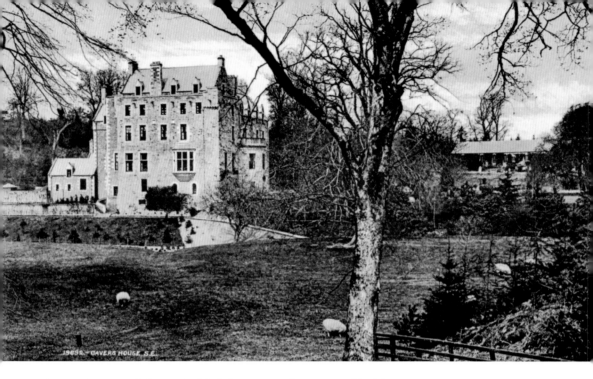

Cavers House and Cavers Auld Kirk, 1902, and Cavers Auld Kirk, 2013
Cavers Auld kirk (above, right), dates back to the twelfth century, although the current kirk was rebuilt in 1622. Originally shaped like a crucifix, three of the parts contained local family tombs and were named the Douglas aisle, the Elliot aisle and the Glestairs aisle. A pended staircase on the outside led to the Laird's Loft (for the Lairds of nearby Cavers House). In the graveyard, which dates to the seventeenth century, you can still see the stump of the old Cavers village cross. Although it difficult to imagine today, this was once a densely populated area, with as many as five public houses and a market square at Townhead.

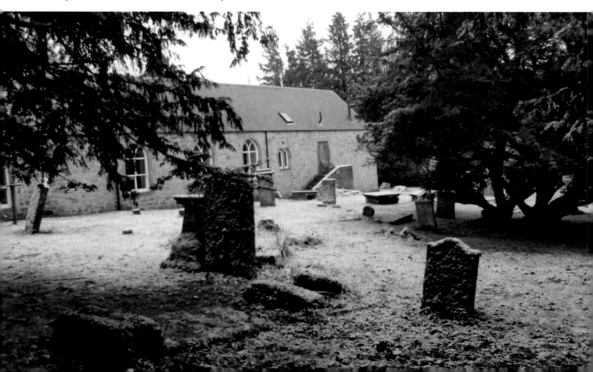

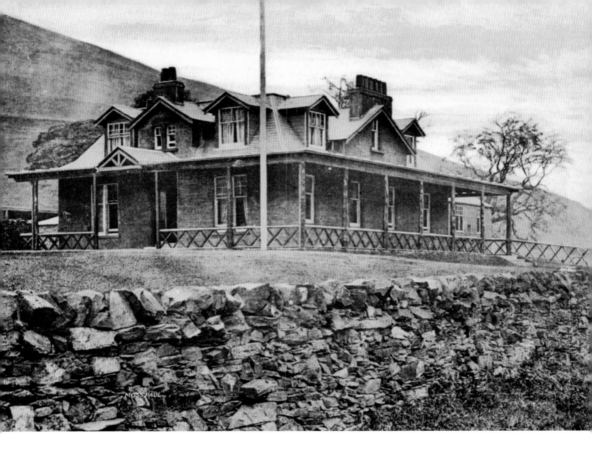

Mosspaul Inn, 1902 and 2011

Mosspaul is situated on the highest point (853 feet) of the main thoroughfare from Hawick to Carlisle. The inn, which first opened in 1750, was an important staging post on the route and at one time housed forty-two stalls for horses. The premises licence lapsed in 1865, and the building lay derelict until 1900, when it reopened with funding from the Mosspaul Club. Following its resurrection, the Cornet and his mounted supporters rode annually over the hills at the invitation of the landlord. Recently refurbished, the inn still plays an important role in the annual Common Riding today.

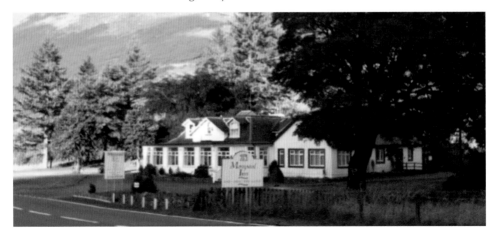

Branxholme Tower, 1902, and Branxholme Estate, 2012

Better known as Branxholme Castle, this was the hereditary seat of the Scotts of Buccleuch from the mid-fifteenth century. The original tower was burned to the ground in 1532 by the Earl of Northumberland, and blown up in 1570 by the Earl of Sussex's force. A corner tower survived and most of the house was rebuilt by Sir Walter Scott and his wife, Margaret Douglas, between 1571 and 1576. Today, Branxholme is listed as a Category A structure by Historic Scotland and remains the property of the Duke of Buccleuch. The estate's name derives from the Old Welsh family name *Branoc*, meaning 'raven'.

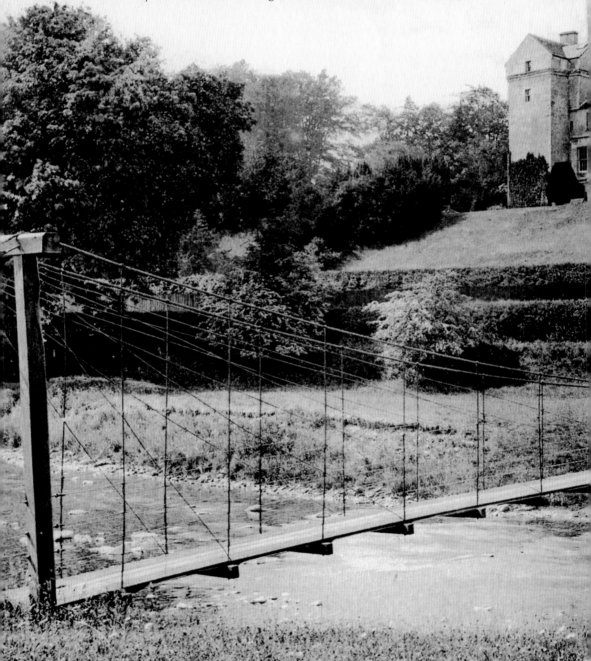

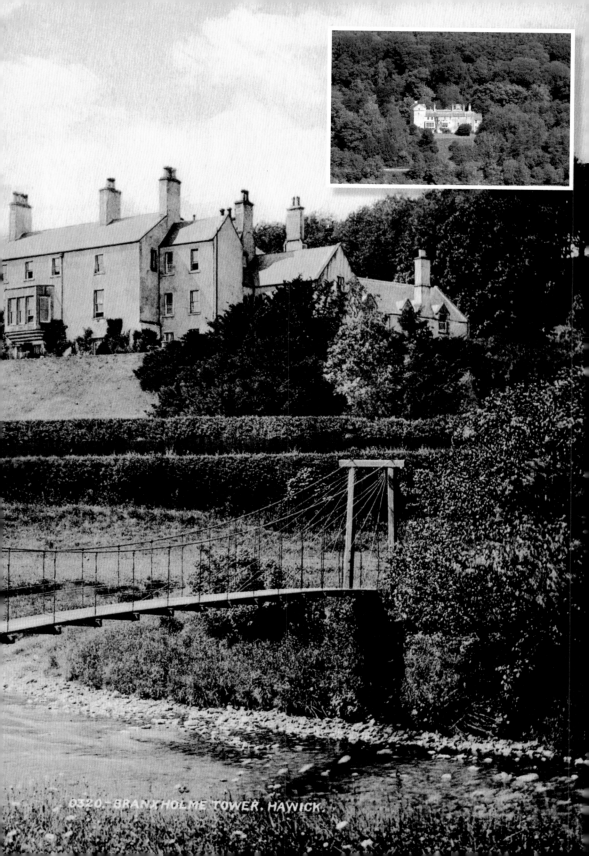

0320 - BRANXHOLME TOWER, HAWICK.

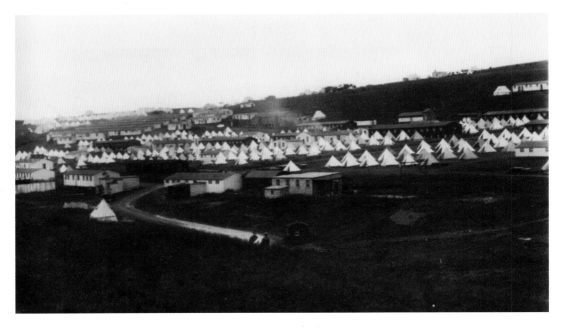

Stobs Military Camp, 1924, Site of Stobs Military Camp, 2014

Stobs estate was sold to the War Office in 1902 for use as a summer training ground for the British Army. Initially used by volunteer forces, the camp became known as the 'Scottish Aldershot' and reached a peak capacity of around 15,000 men by 1915. During the First World War, up to 6,000 German POWs were kept at Stobs, which led to the creation of a German-language newspaper, *Stobsiade*. Following the First World War, it was used to repatriate thousands of Polish troops, before reverting to use as a training ground. The camp closed in 1956, and the land was sold three years later.

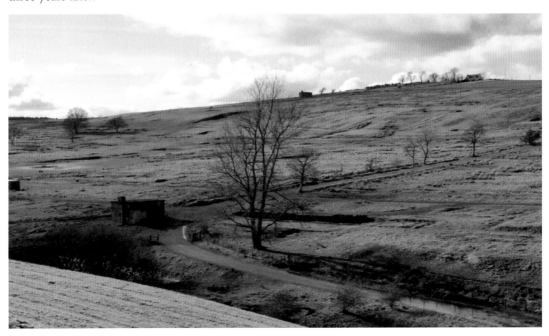

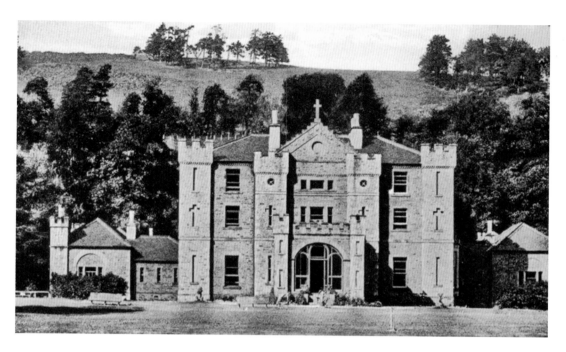

Stobs House, Early 1900s and 2014

Stobs House, sometimes erroneously referred to as 'Stobs Castle', was built in 1792. It was designed by Robert Adam as a residence for Sir William Elliot, and constructed by Hawick firm John Laing. This replaced an earlier house that had been built in 1719. The mansion narrowly escaped being burnt down in 1824, as it was saved by the actions of the servants. The barony of Stobbs was granted to Thomas Cranstoun by King David II of Scotland before 1370. It became a stronghold of the Elliot family during the era of the Border Reivers, when Stobs Castle was built. It burned down in 1712, with most of the ruins reclaimed for contemporary building projects. Today, the site of the castle lies south-east of the main house.

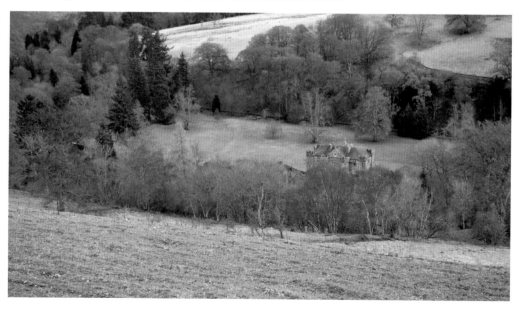

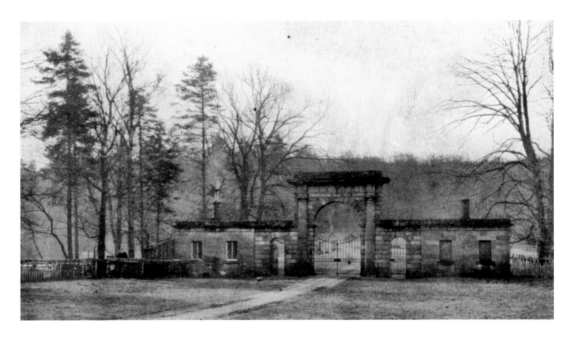

Woodfoot Lodge, *c.* 1906 and 2013

Woodfoot Lodge may be contemporary with Stobs Castle, and it is possible that they were both designed by Robert Adam. However, the gate piers date from the construction of the previous house, which was erected around 1720. During the nineteenth century, it was home to John Grieve (1800–80). Along with his son Robert – one of fourteen children – they started a coach-building business in Havelock Street, Hawick. The original gate lodge was replaced by the present one around 1865, when its position was slightly altered. The Doric-columned archway is flanked by single-storey pavilions. Only the eastern pavilion was ever built, while the other remains purely two-dimensional. The building has been in a ruinous state since being abandoned in 1979.

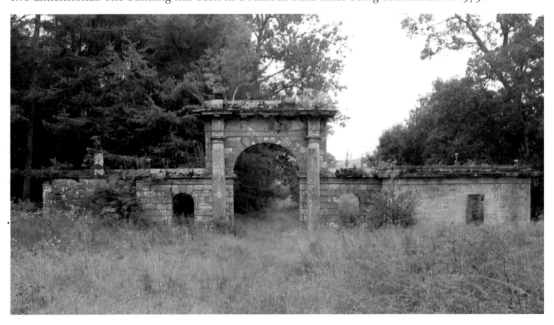

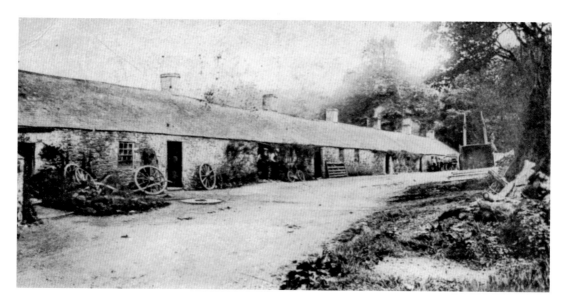

Stobs Village, Late 1800s, and Stobs War Memorial, 2014

Stobs village was once a settlement of half a dozen houses, a blacksmith's and a post office, although little trace remains. Stobs War Memorial is all that is prominent on what is now a quiet country road. Recorded on it are the names of twelve men from the Slitrig Valley who died during the First World War and one local man who died during the Second World War. The memorial was renovated in 2013, with fencing added. Bizarrely, a crater on the surface of Mars was named after Stobs in 1976.

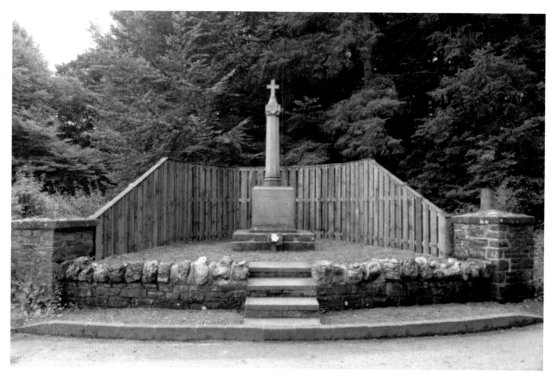

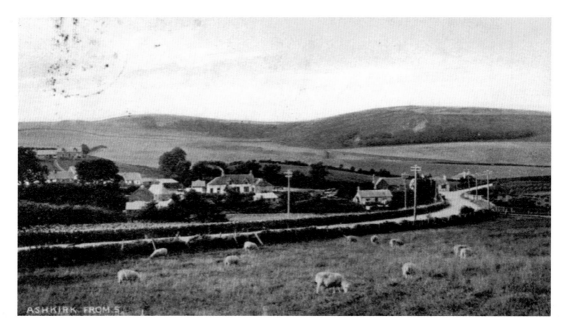

Ashkirk, 1908 and 2014

Ashkirk was once a Burgh of Barony, held as a Prebend of the Bishops of Glasgow from roughly the tenth to the fifteenth century. The earliest church at this site dates back to 1170, although the association with the Bishopric goes back even further. Just off the Woll Rig road lies the Bishop's Stone – a boundary marker set into the ground to define the limits of the former Prebend. Ashkirk became an important staging post during the eighteenth century, with the present church built in 1790. Today, the nearby New Woll estate takes its name from the walled remains of the Bishop's summer residence, which are buried beneath the golf course.

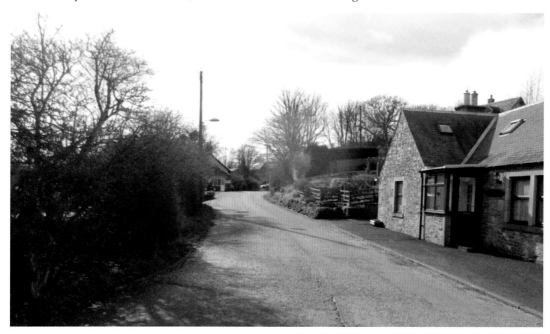

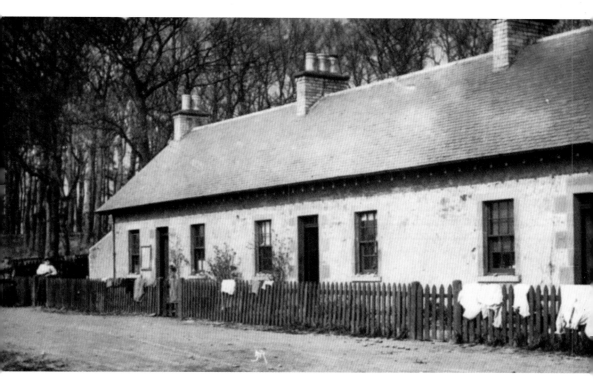

Hassendean Bank Cottages, *c.* 1913 and 2014
These cottages are situated between Hawick and Denholm, on an unclassified road. A hundred years on, the doors have been removed to the rear of the property, while the fencing has been replaced by a neat hedge row. The nearby hamlet of Hassendean had its own railway station for the best part of 150 years, which has since been restored for use as a private residence. The first (1850) and last (1969) stationmasters here are buried at Minto Kirkyard.

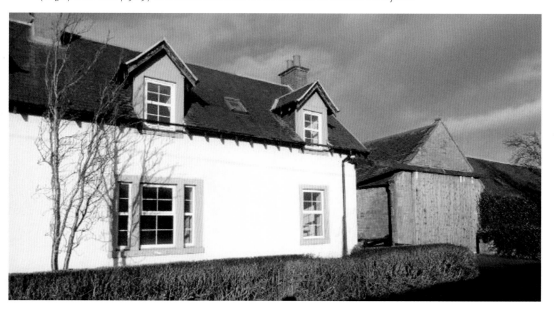

Acknowledgements

The author is indebted to the following people for the use of photographs and information used in compiling this book: Douglas Scott (and his 2002 publication *A Hawick Word Book*), Derek Robertson, Geoff Cryer, Bruce McCartney, Irene Hope, Andrew Rae, Stewart Donaldson, John McNairn, Alexander Cunningham, Malcolm Redpath, Colin Fraser, John Bald, Steven Lothian, Doug Wilson, Paul Francis, Keith Pharo, Sandy Stevenson, Cammy Reith, Jim Barton and Walter Baxter. Additional material was sought from members of Project Hawick.